WATERCOLOUR
FLOWERS

Start to paint with 3 colours, 3 brushes and 9 easy projects

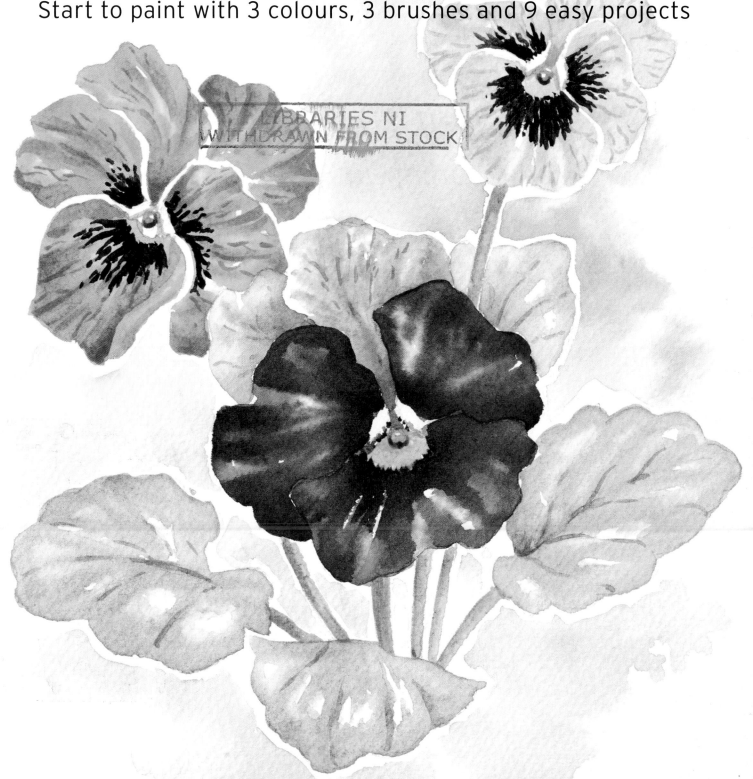

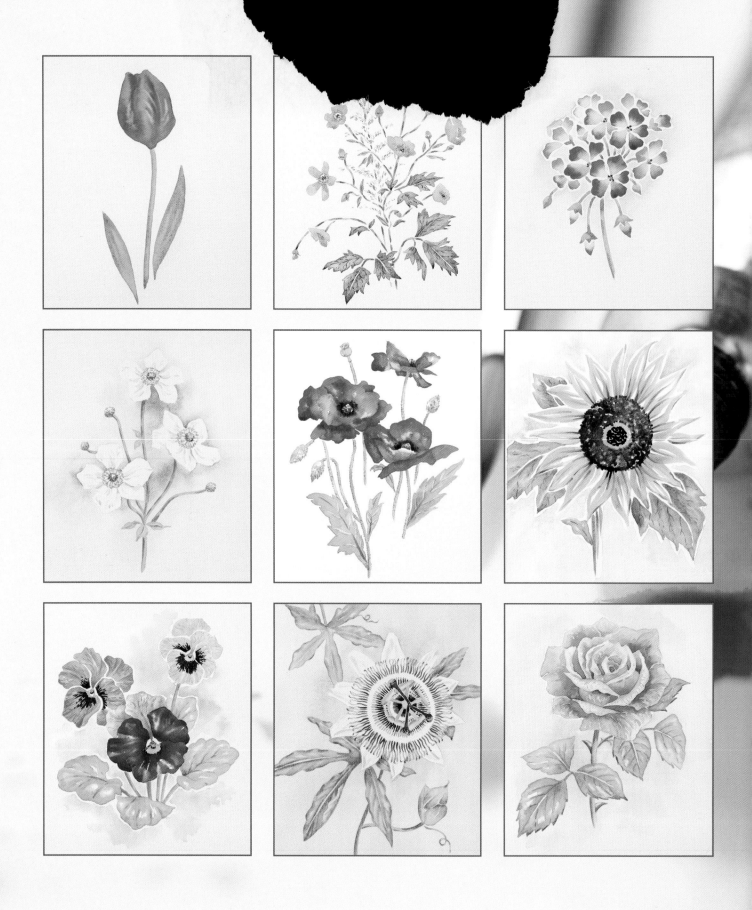

TAKE THREE COLOURS

Julie King

WATERCOLOUR FLOWERS

Start to paint with 3 colours, 3 brushes and 9 easy projects

SEARCH PRESS

First published in 2017

Search Press Limited
Wellwood, North Farm Road,
Tunbridge Wells, Kent TN2 3DR

ISBN 978-1-78221-528-8

The Publishers and author can accept no responsibility for any consequences arising from the information, advice or instructions given in this publication

Suppliers
If you have difficulty in obtaining any of the materials and equipment mentioned in this book, please visit the Search Press website for details of suppliers: www.searchpress.com

To see more examples of the author's work, please visit
www.juliehking.co.uk

Publishers' note

All the step-by-step photographs in this book feature the author, Julie King, demonstrating how to paint with watercolour.
No models have been used.

Printed in Malaysia by Times Offset (M) Sdn. Bhd.

Contents

Introduction

How often do you look at flowers and wish you could put paint to paper to capture their beauty, colours and characteristics in watercolour? *Take 3 Colours: Watercolour Flowers* gives you the opportunity to give it a try. It is your first step on your journey into flower painting.

As an artist and teacher of watercolour painting, I have a wealth of experience in teaching complete beginners and enjoy sharing my expertise to introduce others to this wonderful and therapeutic hobby. I feel privileged to have been given this opportunity to share my passion to encourage, instruct and inspire everyone to pick up a brush and give flower painting a try.

For beginners the vast array of art materials available can be both daunting and costly. This book is a means to introducing you to a new hobby with a minimal amount of outlay, making painting accessible to everyone. For this reason, you require only a basic kit of three colours, three round brushes and a pack or pad of watercolour paper in order to paint the wide selection of projects in this book.

Using a colour palette of just three colours means that you will quickly learn how to mix an amazing variety of vibrant, bright colours and shades. Colour mixing is fascinating and exciting and as you build your painting skills your confidence in colour mixing will grow too.

The watercolour paper you need should be of a good thickness, preferably 300gsm (140lb) in weight, with a 'Not' surface – this means it has a slight texture rather than being smooth. You will soon discover the visual effects of the paint as it settles into the textured recesses of the paper.

The nine flower painting projects I have created for this book are designed to encourage you to learn through doing. Step-by-step demonstrations with easy to follow instructions are a wonderful way of initially learning to paint. Each of my paintings can be traced and transferred onto your watercolour paper to help get you started (see page 64 for instructions).

I have selected a wide selection of flowers with different colours and characteristics from delicate buttercups to a dramatic sunflower. Commencing with the basic techniques you will gradually be introduced to more as you progress though the book and tips will be given along the way.

I hope you will produce some paintings that you feel proud of. Take your time, make yourself comfortable, work at your own pace and above all enjoy it. Use this book as a stepping-stone into flower painting and you will find your life transformed!

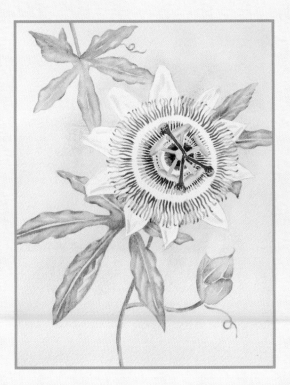
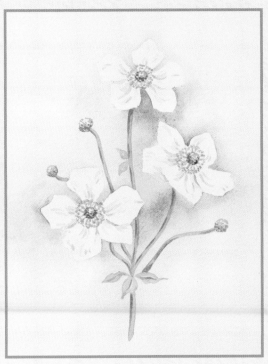

Using the colours

I have selected three colours for all the painting projects in this book: cadmium yellow pale, ultramarine blue and permanent rose.

Yellow

Cadmium yellow pale

Blue

Ultramarine blue

Red

Permanent rose

Preparing your paint

In order to start painting in watercolour, you will need to prepare your paint. Squeeze a small amount of paint from the tube into your palette, then dip the brush into clean water to 'load' it. Take the loaded brush to your palette and let it drip into the palette, then mix.

The strength of a paint's colour will alter depending on the amount of water you add to it. The more water you add, the thinner and weaker the colour will appear when it is applied to the paper. A strong tone is made by mixing the pigment in a palette with very little water, creating a thicker consistency.

JARGON BUSTER

Tone refers to the lightness or darkness of a colour. Adding more water to the paint makes a paler tone – this is called a **tint**.

Consistency or 'thickness'

The red paint on the left has been diluted with plenty of water – note how the mix flows. The blue paint on the right has been left thicker, with a consistency closer to cream.

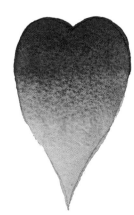

When applied in one consistency, as on the left, the paint is called a 'flat wash'. Varying the consistency by adding water to colour on the paper will allow you to create 'gradated washes', as on the right.

JARGON BUSTER

A **wash** is a mixture of paint and water applied to paper.

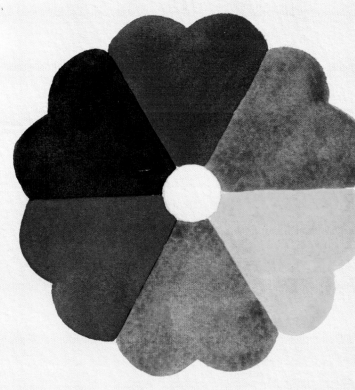

Mixing colours

If you use the three colours just as they are, they are referred to as 'pure' colours. However, by combining them together in your palette or on your paper, you can create lots of extra colours.

Before you start painting each flower, make sure to prepare all the washes you will need for the painting. Instructions for the mixes you will need are listed at the start of each project.

To the left is a colour wheel, which is very important when learning to mix colour. The three primary colours – red, yellow and blue – are placed equidistantly on the colour wheel.

Each primary colour mixed in an equal quantity to the one next to it produces a secondary colour. The secondary colours are orange, green and purple.

Colours opposite each other on the colour circle are known as complementary colours. Two complementary colours mixed together make deeper neutral shades of browns and greys.

Mixing chart

This chart shows a few example mixes. It illustrates the primary, secondary and complementary neutral mixes of colour. Try mixing the colours below and painting them on to a spare piece of paper.

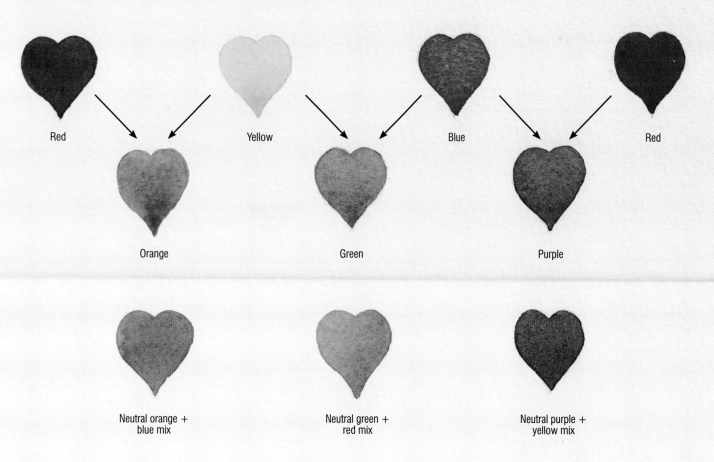

Red Yellow Blue Red

Orange Green Purple

Neutral orange + blue mix Neutral green + red mix Neutral purple + yellow mix

Using the brushes

Only three round brushes are required to complete all the painting projects in this book: a size 10 (large), a size 8 (medium) and a size 4 (small). The large brush is ideal for painting larger washes and even larger details as it is thicker and holds plenty of paint. The medium-sized brush is a good all rounder and the smallest is perfect for painting finer detail.

With experimentation and practice you will discover that the way the brush is held and the amount of pressure applied when putting paint to paper will vary and create a variety of brush marks. To get a feel of the brushes I suggest you spend a little time experimenting.

Painting with the large, medium and small brushes

Make a selection of marks with the three brushes. These can be straight lines, but simple flowers like those shown above are a good way to get started. Get a feel for how much paint you need on your brush and note how simply altering the pressure can change the width of the line.

Large brush

A wide sweeping mark can be made by pressing the brush downwards and sweeping off to make
a finer point to a petal shape or simple leaves.

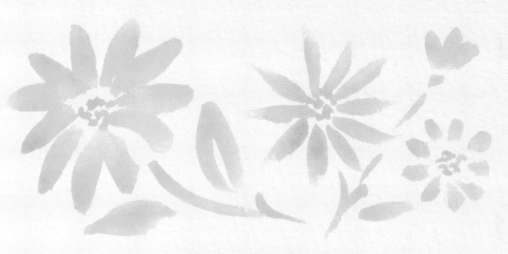

Medium brush

This brush makes a medium-sized brushstroke, suitable for general use.

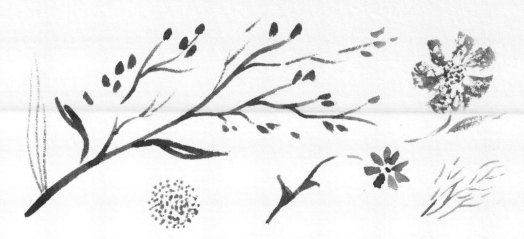

Small brush

This is the perfect brush for finer detail, stems, centres and veins.

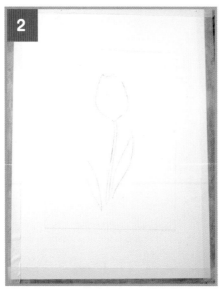

Tulip

What you learn:

- **Mixing colour on the paper**
- **Painting on wet paper**
- **Removing colour**

1 Squeeze a little of each colour paint into separate palette wells. Use the medium brush to make a mauve mix by taking a little of the permanent rose into a new well, then adding a little blue (A). Make two green mixes from yellow and blue: make a light green mix (B) using more yellow than blue and adding lots of water; and a blue-green (C) mix with equal parts yellow and blue.

2 Use masking tape to secure a sheet of your paper to the painting board on all sides. Use a pencil to draw out the basic shapes of the flower – you can trace the shape from the finished painting on page 15. Add a border using a ruler and pencil.

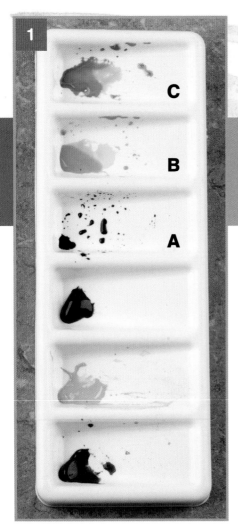

3 To achieve the wet-in-wet effect, dip the large brush into clean water. Tap off the excess, then 'paint' within the pencil lines of the tulip head. You can tell if the paper is wet enough by looking at the paper at an angle – the wet area will shine. Add some watery yellow paint to the lower half of the tulip head, working up from the bottom.

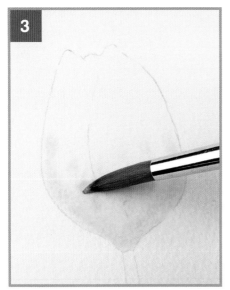

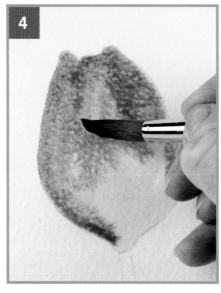

4 Rinse your brush thoroughly and pick up some watery permanent rose . Add this wet-in-wet from the top of the flowerhead downwards so that it will merge with the damp yellow paint. These two colours will mix on the paper to create an orange effect.

JARGON BUSTER

Wet-in-wet As the name suggests, this is when you add paint to a part of your painting that is still wet. The colours will merge and blend together on the surface.

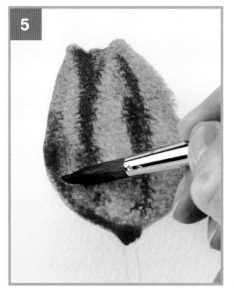

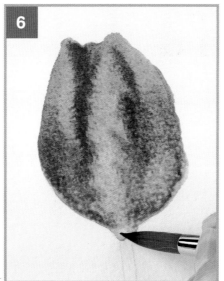

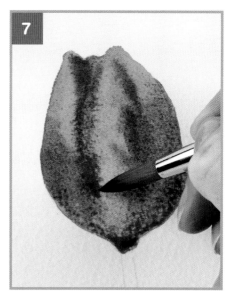

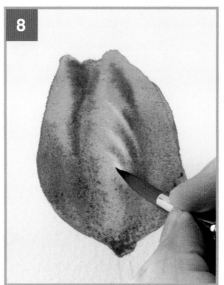

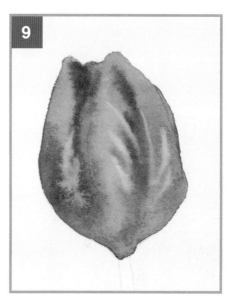

5 Use the point of the large brush to pick up some stronger (i.e. less diluted) rose. Apply it in downward brushstrokes to suggest the shadows and shapes of the petals.

6 If the paint begins to pool and form a droplet, rinse and dry your brush. Touch it to the droplet and it will absorb some of the excess.

7 Add some of the mauve (A) in the same way as the stronger rose to add shadow on the right-hand side and in the recess between the petals.

8 Clean and dry the medium brush so that it is only slightly damp, then press it down quite firmly and draw it in a sweeping motion in the direction of the petal growth to gently remove some colour, leaving lighter areas as shown.

JARGON BUSTER

Removing wet colour by drawing it into the bristles of a dry brush is called **lifting out**. It is a good way to add light areas and highlights.

9 Rinse and dry your brushes and allow the flowerhead to dry.

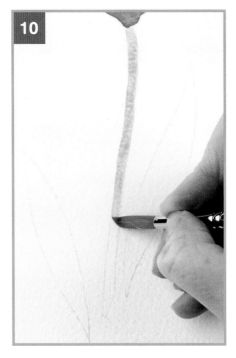

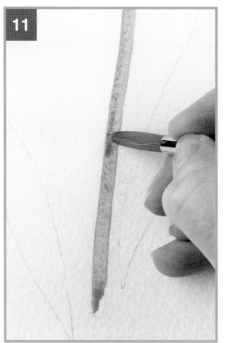

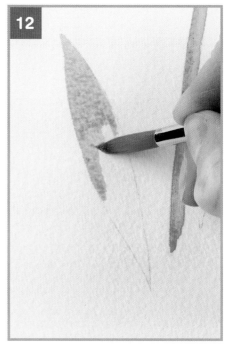

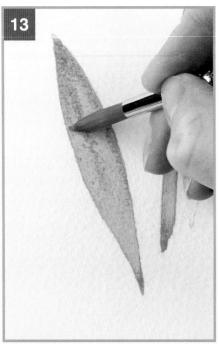

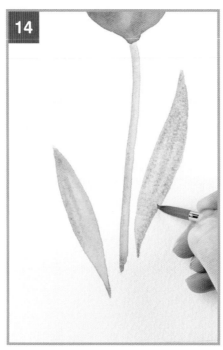

10 Use the medium brush to paint the stem with the light green mix (B). Start from the top and work down.

11 While the green is still wet, pick up some of the dark green mix (C). Using the point of the brush, draw it down the left-hand side of the stem. The deeper green will flow over the paler one to suggest the curve of the stem.

12 Rinse the brush, then paint the left-hand leaf with the light green mix (B), again starting from the top and filling the whole shape.

13 While it remains damp, use the stronger mix to add some simple details. Draw the point of the brush from the tip of the leaf down part of the side edges and in to the middle to suggest a vein.

14 Paint the second leaf in the same way. Don't worry if the leaves look slightly different in tone – nothing in nature is perfectly identical.

Tip
Clean your brushes, wash out the mixing wells of your palette and refresh your water pot before you start the next painting.

Your first finished painting! In the next project you will paint both the flowerheads and leaves on dry paper before dropping in stronger colours.

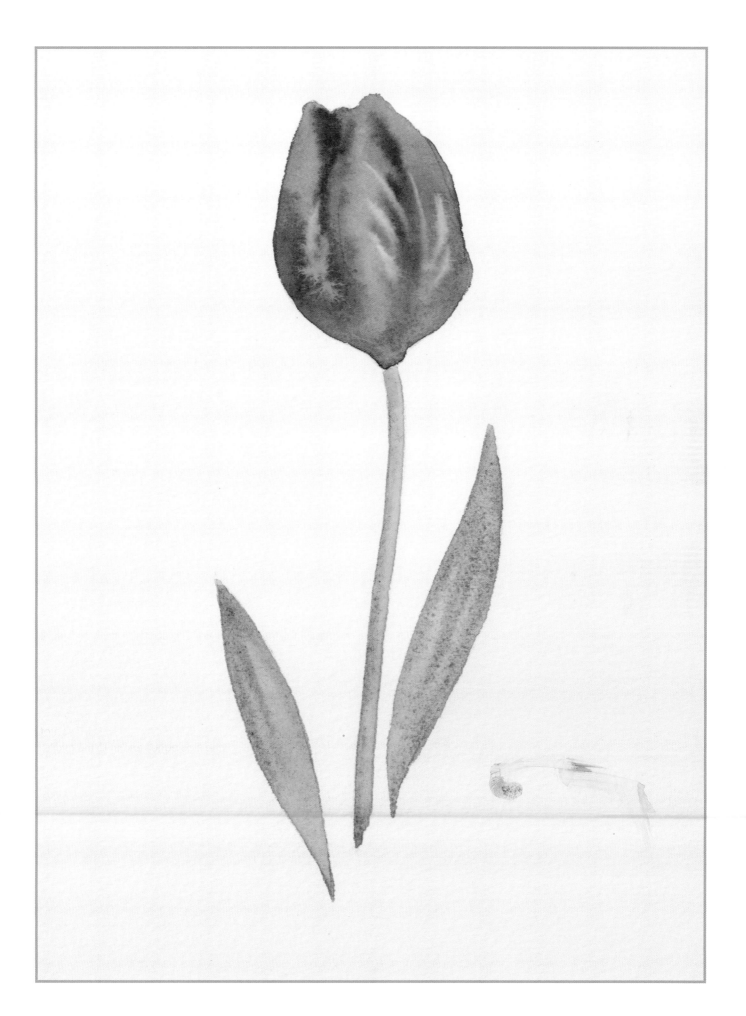

Buttercups

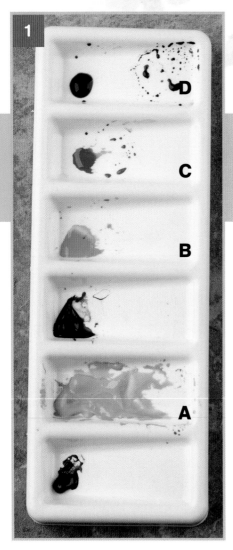

What you learn:

- **Painting simple leaves and stems**
- **Adding fine details**
- **Painting veins**

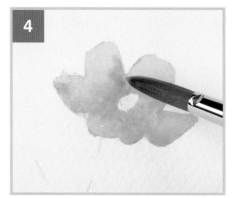

1 Prepare your mixes. For this painting, in addition to the prepared pure colours, you will need an orange mix (A) of yellow with a little rose added; yellow-green (B), a mix of yellow with a little blue; blue-green (C), a mix of yellow with more blue; and mauve (D), a mix of blue with a little rose and a touch of yellow.

2 Secure the paper to the board using masking tape and transfer the image (as described on page 64). Keep the outline drawing of the buttercup flowers faint, otherwise it will show through the yellow paint.

3 Use the large brush to paint a watery yellow wash on the first buttercup head. Leave a little space in the centre as shown. Using the tip of the brush, drop in a little of the orange mix (A) to the wet centre and the edges.

4 Rinse your brush and add some yellow-green (B) touches wet-in-wet.

5 Paint the other flowers in the same way.

JARGON BUSTER

Wet-on-dry painting is simply applying your prepared paint on to dry paper.

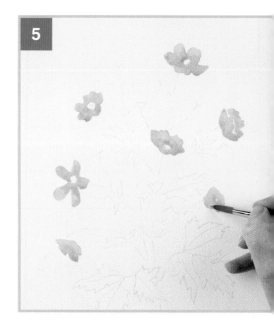

JARGON BUSTER

Applying a stronger paint to a wet background with the tip of the brush is called **dropping in**.

6 Paint the buds with the same brush and mixes, adding the yellow first, then touching in orange (A) on the tips.

7 Allow the painting to dry, then change to the small brush. Stipple the yellow-green mix (B) into the centres, leaving a little white showing. When dry, add a few dots of dark green (C) over the top.

8 Add a little more permanent rose to the orange (A) to strengthen it and paint tiny dots around the centres. Pay attention to the shape of the petals – some may obscure the centres, avoid the area when you are stippling.

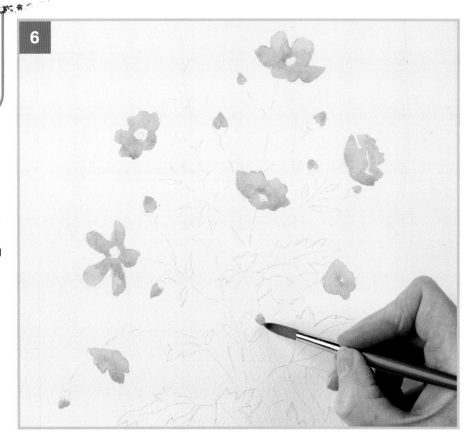

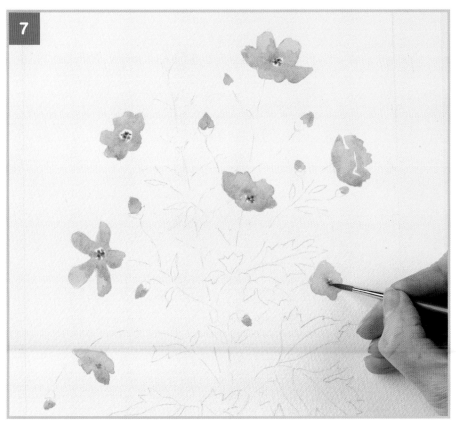

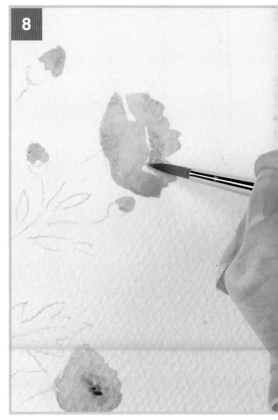

JARGON BUSTER

Stippling is the name for building up a dotted effect using the point of the brush.

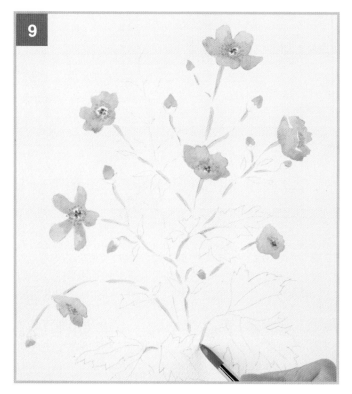

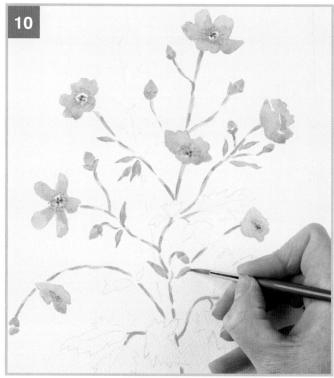

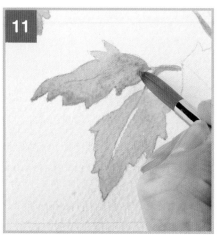

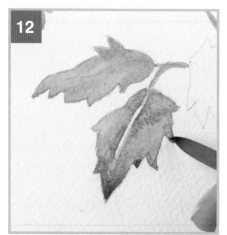

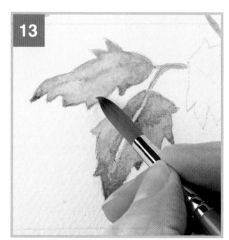

9 Use the medium brush to paint the stems with yellow. Do not paint continuous lines; instead use broken strokes for a looser effect.

10 Use the small brush to paint slightly thicker yellow-green (B) on top of areas of the yellow stems. Paint the bud sepals and small leaves at the same time.

11 Change to the medium brush and start to paint the large leaves with the yellow-green mix (B), leaving a gap for the central veins in some before dropping in areas of blue-green (C).

12 Add touches of neat blue paint wet-in-wet.

13 If the paint dries before you have completed a leaf, allow the painting to dry completely, then re-wet the area with clean water and continue as before.

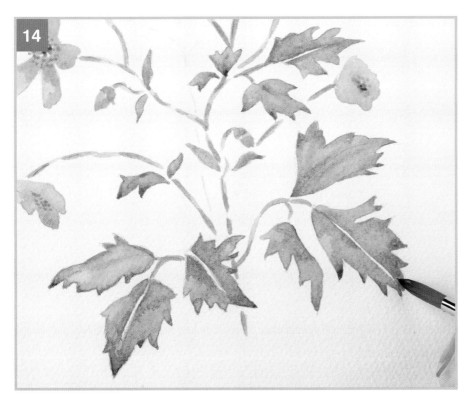

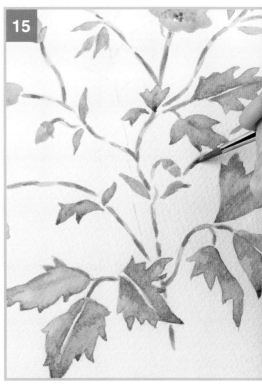

14 Paint the remaining large leaves in the same way.

15 Add a hint of permanent rose to the blue-green mix (C) and add a few darker touches to the stems using the tip of the small brush.

16 Add a few hints of the same mix on the bud sepals and small leaves.

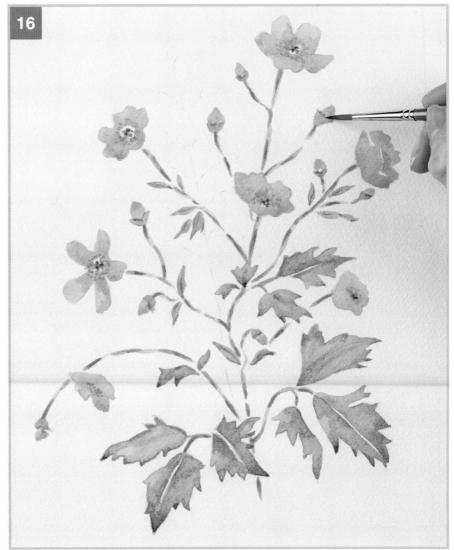

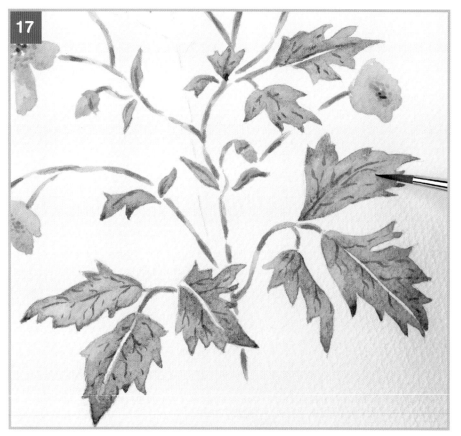

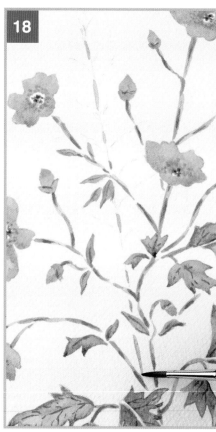

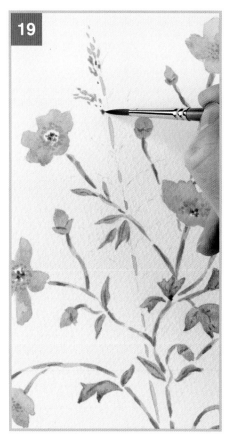

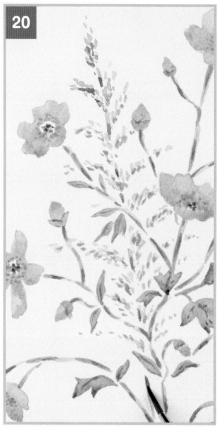

17 Add veins using the tip of the brush to draw very fine broken lines away from the centres of the large leaves.

18 Still using the small brush, paint the background grass stem with the mauve mix with a similar broken line to the buttercup stems.

19 Use the tip of the brush to add tiny touches of mauve to suggest the seedheads which lead to the main stem.

20 Reinforce areas with a stronger version of the mauve mix (D).

In the next project you will learn how to paint a bright pink geranium, made up of several flowerheads, against a soft background.

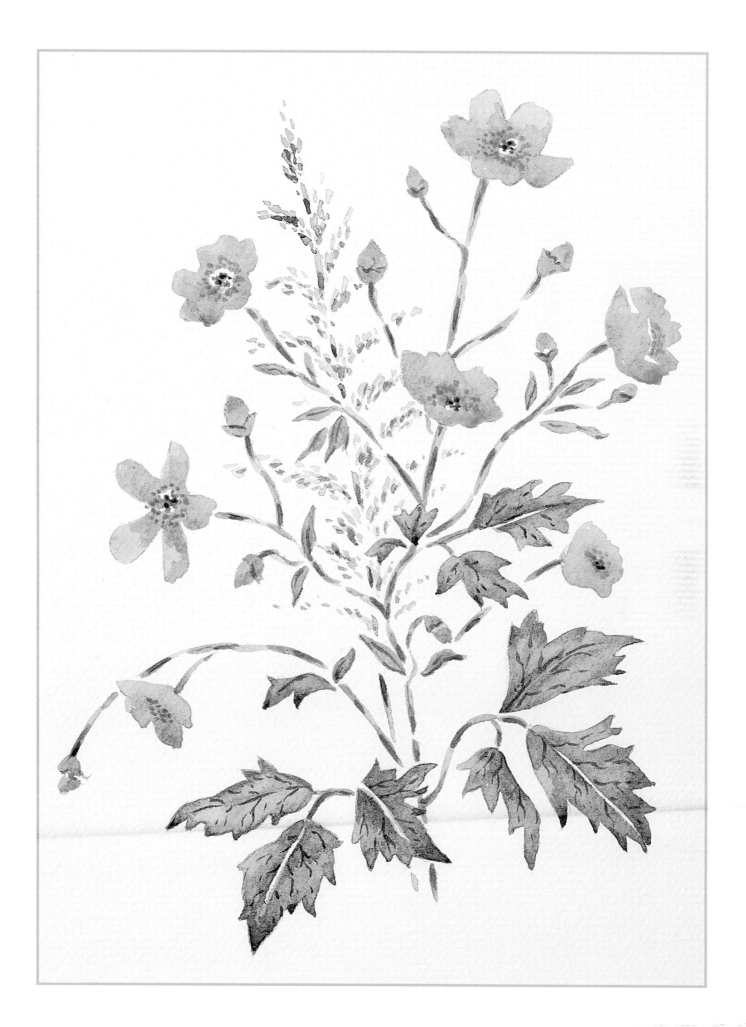

Geranium

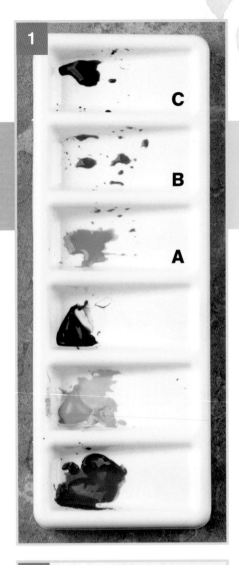

- **Fading colour out for petals**
- **Adding a simple background**
- **Using the tip of the brush**

1 Prepare the following mixes: green, from an even mix of blue and yellow (A); earth-green, the same mix with an additional touch of rose (B); and mauve from rose and blue (C).

2 Secure the paper to the board with masking tape, then transfer the image using a pencil, as described on page 64.

3 Starting on the lowest flowerhead, use the medium brush and a creamy consistency of rose to paint the outer edge of one of the petals.

4 Rinse the brush, remove the excess water, then draw the colour towards the centre of the flowerhead with the damp brush. Note how the colour fades out.

5 Paint the other petals near the centre in the same way.

6 Being sure to keep the colour strong on the outer edge and paler near the centre, paint the other strong central flowers using the same technique.

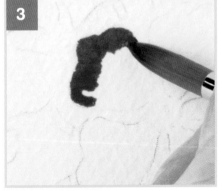

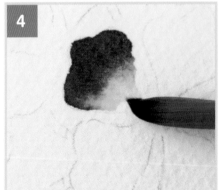

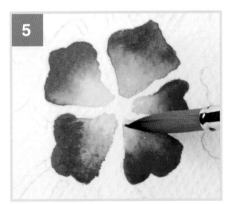

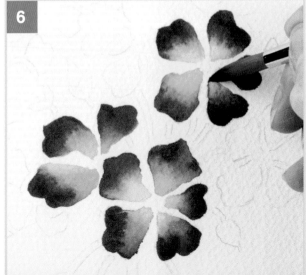

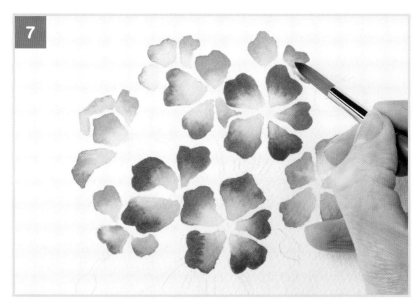

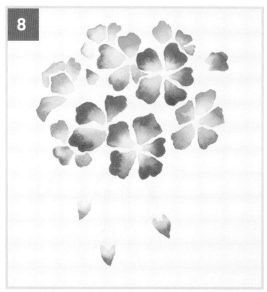

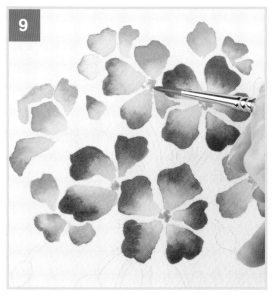

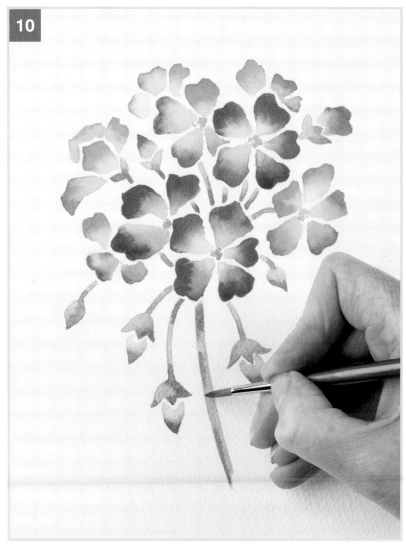

7 Dilute the rose a little. Using this lighter tint to start, paint some of the surrounding petals in the same way as before. Because you are starting with a paler tone, the effect will be paler overall.

8 The buds are painted in a similar way, darker at the tip and paler towards the stem.

9 Using the tip of the small brush, add the flower centres with a few loose brushstrokes in the light green mix.

10 Paint the stems with the green mix (A). While it remains damp, touch in some of the earth-green mix (B) to add variation and shading.

Tip

To make an earthy shade of green, add a touch of rose to the mix. See page 9.

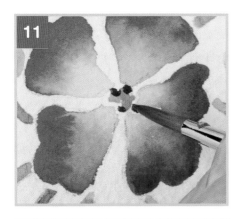

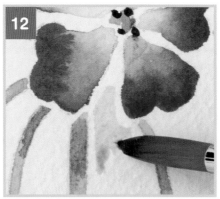

11 Using a creamy mix of rose with a touch of blue, add dark stamens to the flower centres.

12 Allow the painting to dry, then use an eraser to remove any pencil lines. Use the medium brush to apply the mauve mix (C) to the background near the flower. Leave a thin gap of clean white paper between the background and the flowers, stems and buds.

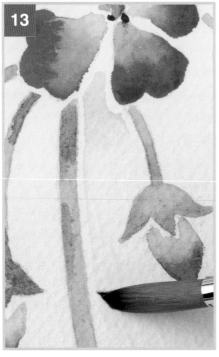

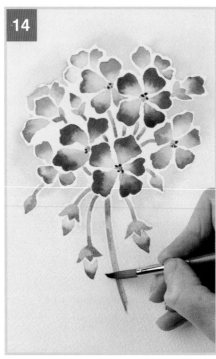

JARGON BUSTER

Fading out is a method of adding water to dilute a stronger wash on the paper. This produces a 'gradated wash'.

13 Rinse the brush and draw out the colour towards the edge of the picture, fading it away to nothing.

14 Work round the outside of the flower section by section, aiming to match the colour each time. It can help to turn the board around when you are working near the top of the flower.

15 Paint spaces inside the flower using the same mix (C). Leave gaps by the petals and stems as before, but there is no need to blend it away on the inside areas.

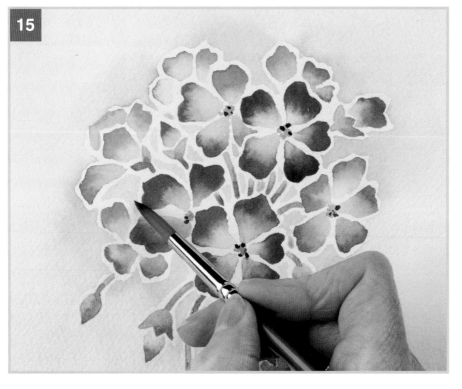

Tip

Paler tones in the outer petals make the overall flowerhead look rounder.

In the next project you will learn an effective way of painting white flowers without using white paint!

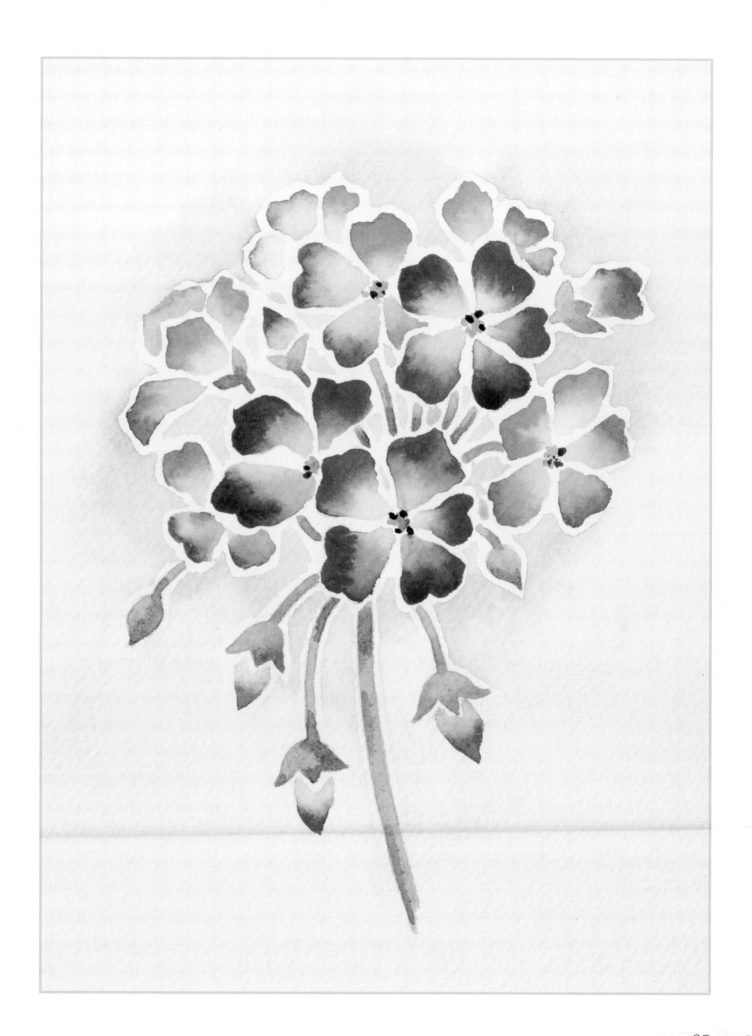

Japanese Anemone

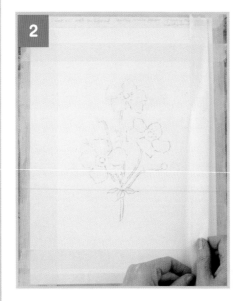

What you learn:

- **Painting white flowers**
- **Starting a painting with the background**
- **Painting shadows**

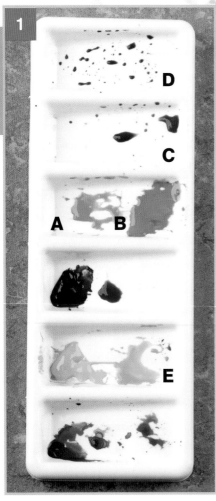

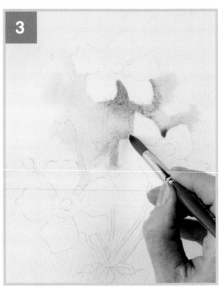

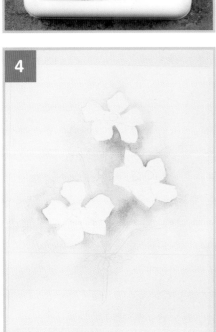

1 Prepare a light green mix (A) and a dark green mix (B) as for the tulip (see page 12). Make a mauve grey (C) by combining all three of the colours: add a little rose to watery blue, then add a minute hint of yellow. Make a second, more watery, paler mauve-grey (D). Make a golden orange mix (E) from yellow with a hint of rose.

2 Secure the paper to the board with masking tape, then draw out the shapes as before. Add extra strips of masking tape around the pencil border and press them down firmly. This will give you an area to work towards and ensure a clean finish.

3 Wet the surface of the background – the negative spaces – with clean water and the large brush. Avoid the white flowerheads, using the tip of the brush to work around and in between the petals. Pick up some watery blue on your brush and touch it to the wet surface. Allow it to bleed into the water. Gradually draw it across the surface, letting it soften into the background.

4 Continue until the background is filled, working right up to the masking tape borders. Keep the colour strongest near the flowerheads and let it fade out towards the edges. Allow the painting to dry completely. If the paper has buckled slightly, it will flatten naturally as the paper dries.

JARGON BUSTER

Negative spaces are the areas surrounding and between the positive shapes– i.e. the flowers. In this painting, it is the background.

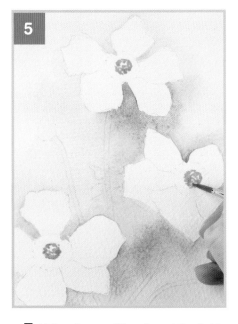

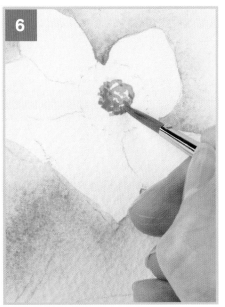

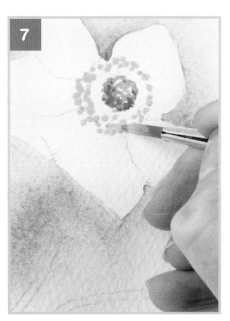

5 Using the small brush and the light green mix (A), paint the flower centres with light touches using the point of the brush.

6 Once dry, repeat the process with the dark green mix (B), concentrating on the lower part of each flower centre to indicate the shadow, roundness and texture.

7 Rinse the small brush and use pure yellow at a creamy consistency to stipple around the green centre, leaving a white band between them.

8 Use the tip of the brush to draw fine lines from the yellow into the green to suggest the stamens. Repeat on the other flowers, then allow to dry.

9 Add more strength to the yellow areas by stippling the warm golden orange mix (E) on top, then add a few short lines of the lighter green mix (A) to give variation.

10 Where one petal overlaps another, use the small brush to apply the more dilute mauve grey mix (D). Rinse your brush and use the tip to draw out and diffuse the colour.

11 Add fine directional sweeping brushstrokes to suggest the curves, shadows and movement of the petals, using the same brush and mix.

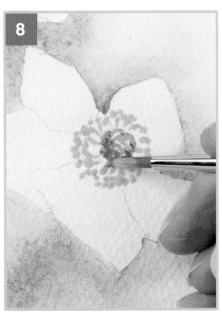

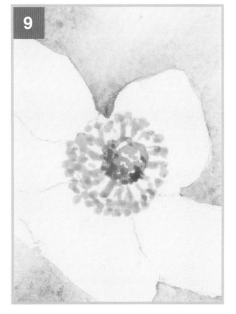

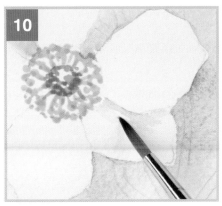

Tip

When painting white flowers, leave plenty of white paper in order to keep them bright and fresh.

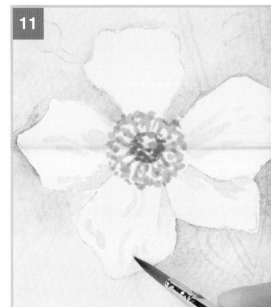

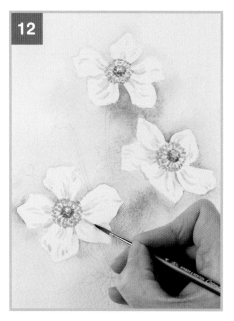
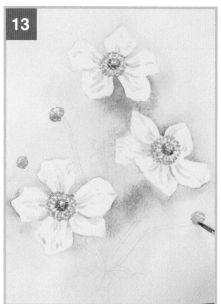
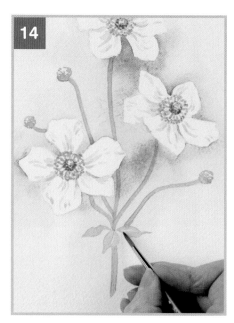

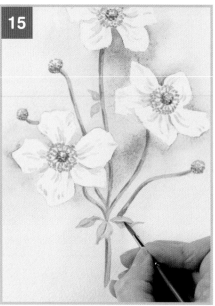
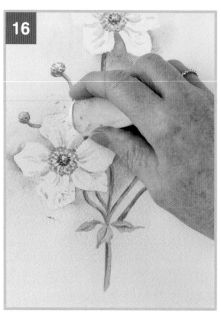

12 Using the stronger mauve grey (C) mix, add shadows to the existing grey areas. This gives the painting more contrast and makes the flowers appear brighter.

13 Stipple the seedheads using the lighter green mix (A) and the small brush.

14 Paint the stems wet-on-dry using the small brush and the light green mix (A). Paint from the top of the stem downwards with one fluid motion of the brush. Add the leaves with the same brush, leaving a gap in the centres.

15 When dry, use the dark green mix to add shading in the form of a broken brushstroke on the side of each stem. Add central veins in the leaves and stipple the underside of the seedheads.

16 Make sure the painting is thoroughly dry, then use an eraser to gently remove the pencil lines. Remove the masking tape to finish.

In the next project you will be shown how to let colours mix to create rich, vibrant red poppies.

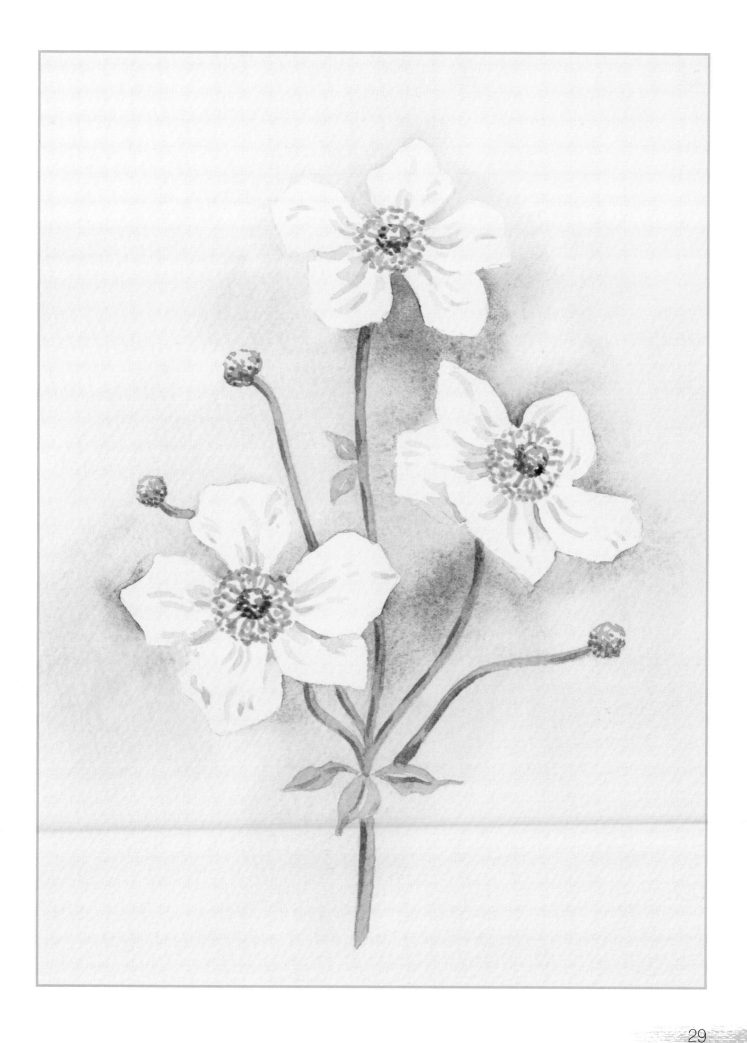

Poppies

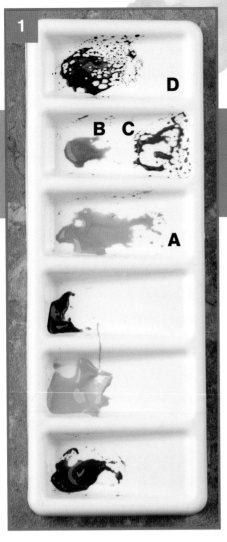

What you learn:

- **Painting vibrant colours**
- **Dropping in water**
- **Tiny marks for texture**

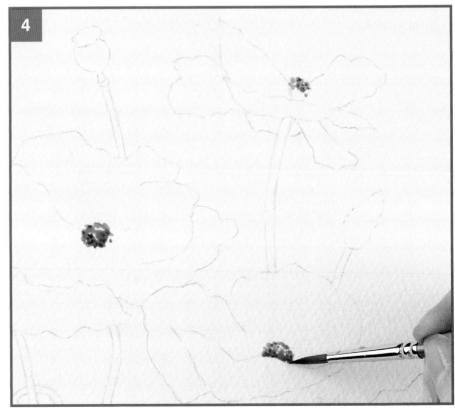

1 Prepare the following mixes: light green, from yellow, with a touch of blue (A); mid-green, from yellow with more blue (B); dark green, with yellow with lots of blue (C); and mauve, rose and blue, with a little yellow (D).

2 Secure the paper to the board with masking tape, then transfer the image using a pencil, as described on page 64.

3 Stipple the centres of the poppies using the tip of the small brush to apply the light green mix (A) in dots.

4 Once dry, sparingly stipple the dark green mix (C) over the top. Try to leave a few white spaces visible between the brushmarks.

5 Swap to the large brush. Prepare strong pools of pure yellow and pure rose. Commencing at the poppyhead on the left, apply areas of yellow wet on dry.

6 Quickly rinse the brush, then paint in areas of rose while the yellow is still wet. Allow the wet paint to mix and blend where it touches, as well as producing different shades of rose, the yellow will combine with the wet rose paint to make a variety of oranges and hot reds.

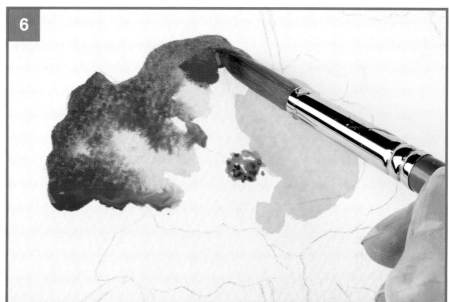

7 Drop in creamier, thicker rose paint wet-in-wet with the tip of the brush, aiming to suggest shape and individual petals.

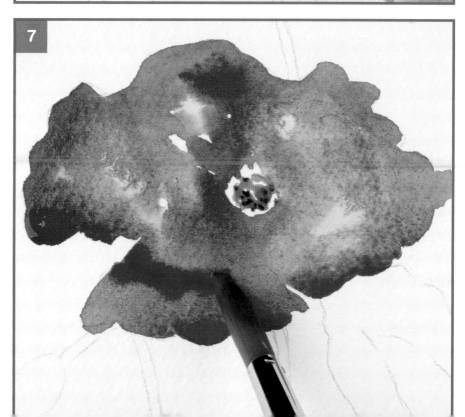

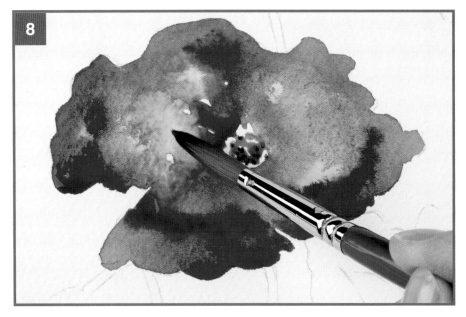

8 While the paint remains slightly damp, drop in pure water with the medium brush. This will push aside the wet colour and create a textured highlight.

9 While the first poppy dries, start to paint the others in the same way. Change to the medium brush for a little more control on the smaller poppy at the top.

10 When painting the final large poppy, either wait for the first to dry completely, or leave a tiny gap where it overlaps.

11 Allow the paint to dry. Use the medium brush to define the deeper shadowed areas underneath and between petals by applying a wet-on-dry brushstroke in a creamy rose consistency, then rinsing the brush and fading out with water.

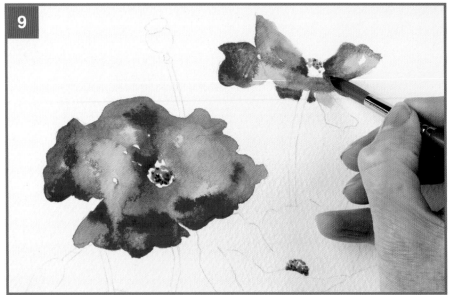

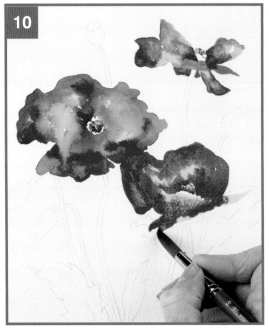

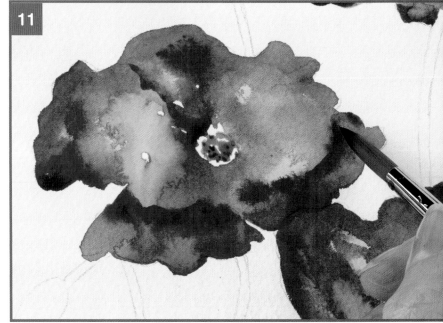

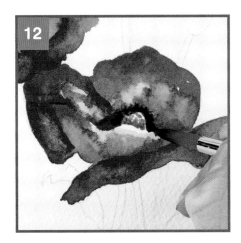

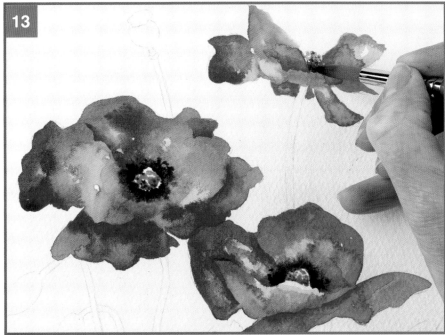

12 Once dry, re-wet the area around the centre of the right-hand poppy with the medium brush and clean water. Stipple the mauve mix (D) at a strong consistency – very little water – into the wet area.

13 Repeat for the left-hand poppy. For the top poppy, there is no need to wet the area; just stipple the paint on.

14 Paint the buds with a fluid mix of the light green (A), using the small brush. Apply the paint in short strokes and leave areas of white paper to create texture.

15 Paint in the stem with long, smooth strokes from the top to the base, then touch watery blue into the wet paint on both the bud and the stem.

16 Paint the other buds and stem in the same way. Using the same colours, paint the seedhead at the top.

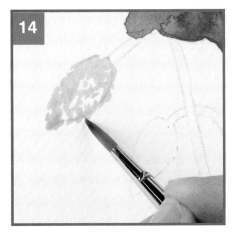

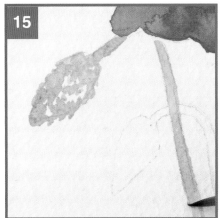

Tip

Colours appear more vibrant and exciting when they are applied side by side and allowed to blend together whilst wet.

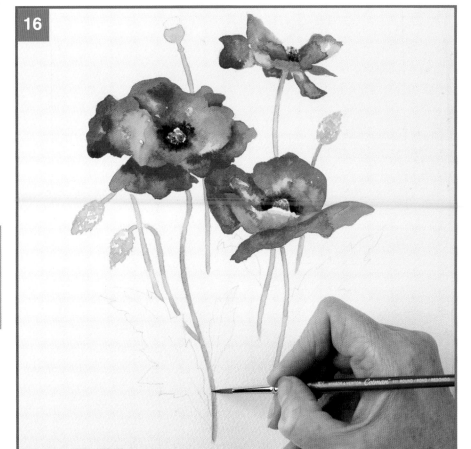

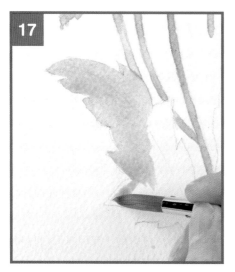

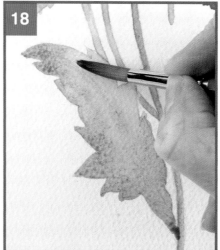

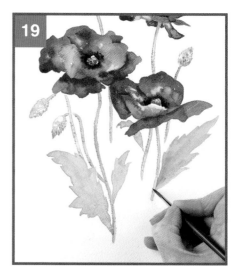

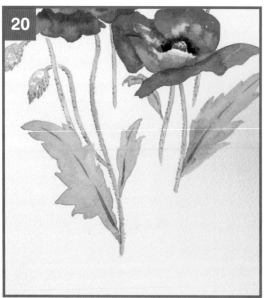

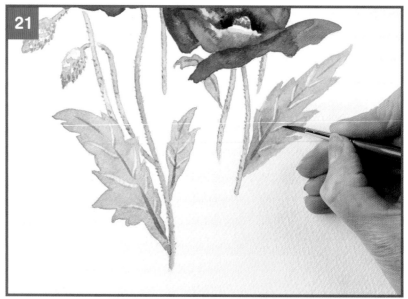

17 Using the medium brush and the light green (A) mix, apply a base wash on the large leaf on the left. Starting at the tip, paint around the edges and draw the paint approximately three-quarters of the way down the leaf.

18 Using a dilute blue mix, continue painting the lower section, sweeping upwards from the base and along some of the edges.

19 Paint the other leaves in the same way. Allow the paint to dry, then use the tip of the small brush to give an impression of fine hairs on the stems and buds with the dark green (C) mix.

20 Continuing with the small brush, add central veins to the leaves using the dark green (C) mix. Draw the brush from the base of the leaf upwards so that the veins taper towards the tip.

21 Wet the small brush with clean water. Dry the brush slightly, press down firmly and lift out light veins on each leaf. Load the small brush with the mid green mix (B) and sweep a loose line against the edge of the light vein.

22 To finish, use a dilute orange mix of yellow and rose to paint the top of the seedhead, then touch in a little green detailing with the mid-green mix (B).

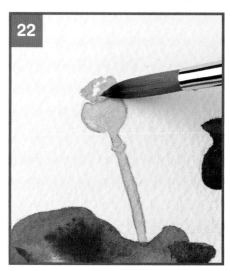

In the next project you will combine freehand brushstroke petals with some of the techniques we have covered earlier in the book.

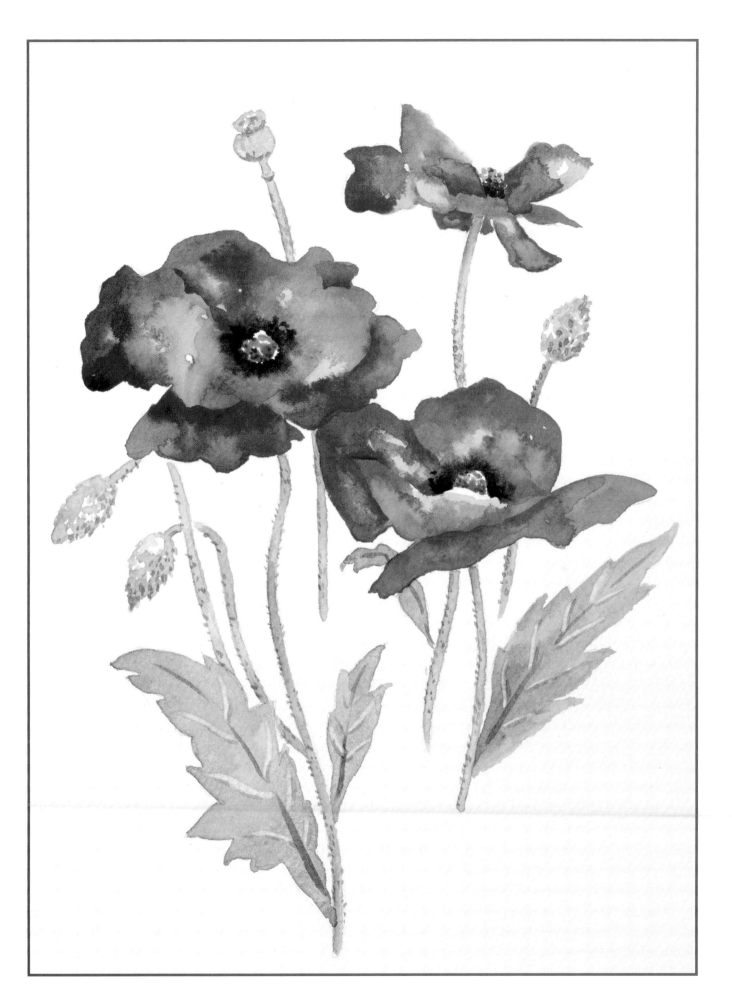

Sunflower

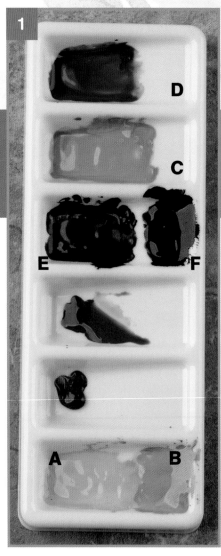

What you learn:

- **Mixing dark colours**
- **Freehand work**
- **Painting variegated backgrounds**

1 Prepare your mixes. For this painting, you will need a warm gold (A) of yellow with a hint of rose; an orange mix (B) made from yellow with more rose; a yellow-green mix (C) of yellow with a little blue; blue-green (D), made from yellow with more blue; a purple mix (E) of rose with a little blue; and a dark purple mix (F) of equal parts rose and blue plus a small amount of yellow.

2 Secure the paper to the board and transfer the image before applying masking tape around the border. Draw only the main ring of petals as shown – we will paint the rest freehand.

3 Working from the outer line of the centre, use the warm gold (A) to paint the petals. Load the large brush with paint, press downwards and gradually lift the brush so as to create a point at the tip of the petal. Make two or three strokes side-by-side, leaving a small gap in the centre to suggest a highlight.

4 Paint the other petals that overlap the leaf at the bottom in the same way, then continue working anti-clockwise round the flower centre.

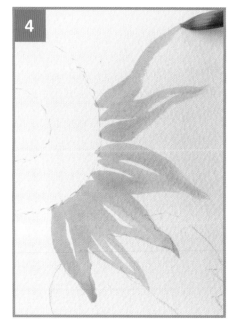

5 Continue adding freehand petals as you work round the centre. The pressure you use will affect the width of each brush stroke. You can twist the brush to help give movement.

6 Continue all the way round – you might find it helpful to rotate your board to avoid stretching across wet paint.

7 Wet the whole central circle with clean water, then use the large brush to paint the inner circle wet in wet using the yellow-green (C) mix and a dabbing motion of the brush.

8 Leave the yellow-green paint to dry slightly, and stipple the orange mix (B) into the surrounding area, leaving a few gaps. Overlap the edges of the yellow-green centre.

9 Switch to the medium brush and add touches of the purple mix (E) wet in wet over the orange area. Leave small gaps so that the orange base shows through.

10 Rinse the brush and add fine brushstrokes of the orange mix (B) onto the yellow petals to indicate shadows and veins. If the centre is still damp, drag a little colour from it into the veins. If the centre has dried, apply the dark purple mix (E) wet on dry.

JARGON BUSTER

Freehand work is a method of painting directly with the brush, rather than working within a pencil outline.

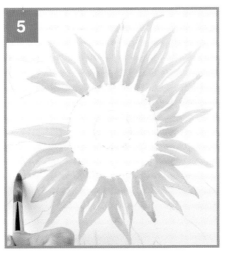

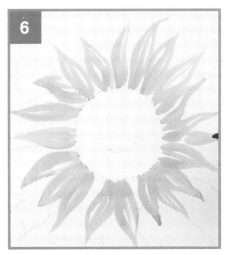

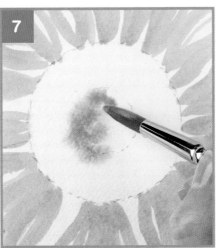

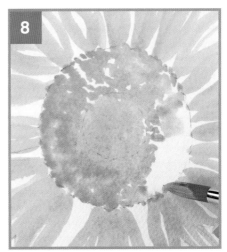

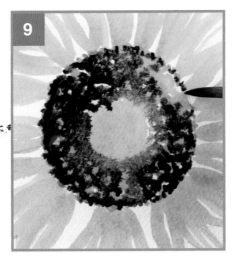

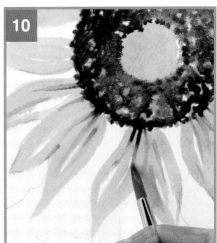

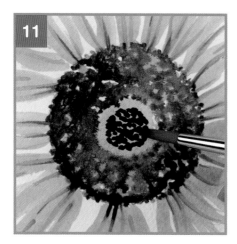

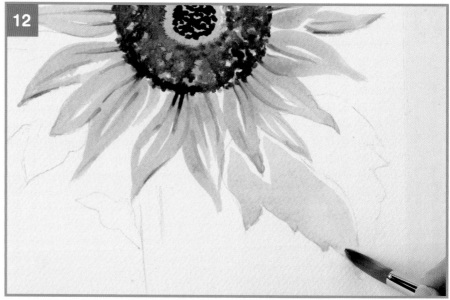

11 Once dry, using a creamy consistency of the dark purple mix (F) add detailing to the centre with dabbing brushstrokes.

12 Using the large brush, apply a watery wash of the warm golden mix (A) on the large lower leaf. Leave a fine gap of white paper surrounding the petals.

13 Without rinsing the brush, pick up the yellow-green mix (C). While the leaf is still damp, apply brushstrokes along the edge of the central vein; in the direction of the secondary veins; and on the edges.

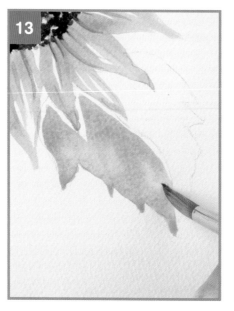

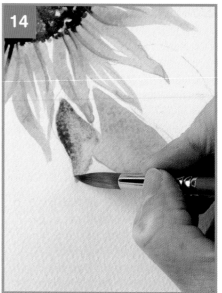

14 While still damp, use the medium brush to apply the watery blue mix on top of the previous brushstroke in order to give more depth and shading.

15 Repeat on the other half of the leaf, leaving a white gap for the central vein, then paint the other leaves in the same way.

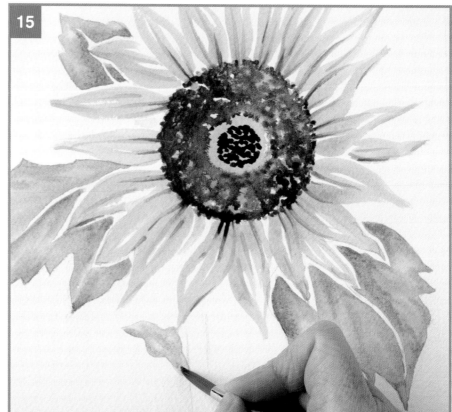

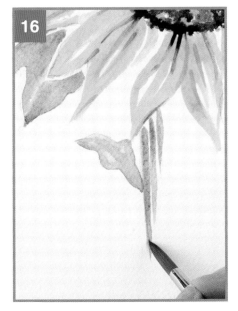

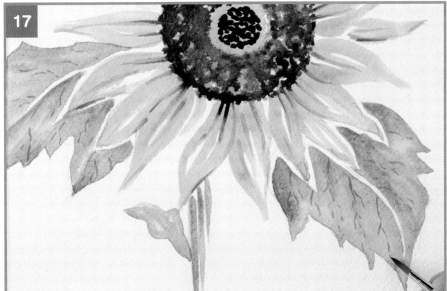

16 Use the same brush and colours to paint the stem, but use long vertical strokes, leaving fine gaps of white, to suggest the ridges and texture. Taper the brushstrokes to a fine point so that the stem appears to fade away.

17 Once dry, use the tip of the small brush to suggest veins on the leaves with the blue-green (D) mix.

18 Using the large brush, wet the top half of the painting with clean water up to the edge of the masking tape, leaving a small gap around the leaves and petals. Working wet-in-wet, paint in a very watery blue.

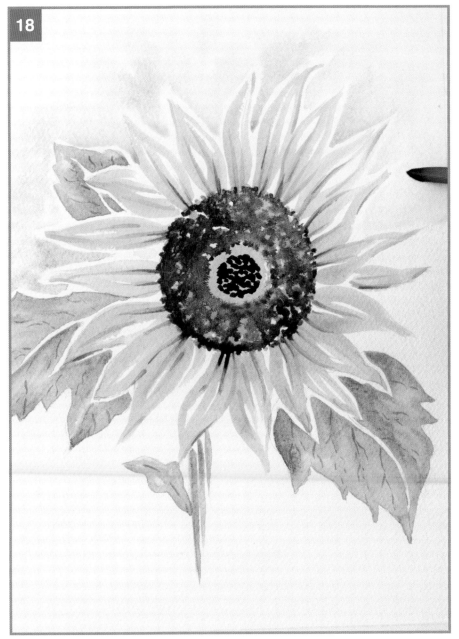

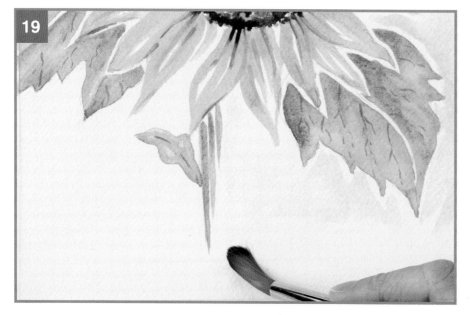

19 Start to paint the lower half of the background in the same way, leaving a dry area of paper around the stem. Apply a dilute pure yellow mix on top. Start where the blue background finishes.

20 Continue to the left of the stem and, while the paint remains wet, drop in a very watery blue between the petals and alongside the edges of the leaf using the medium brush. If the blue is still damp on the top right corner, a touch of very dilute purple mix (E) could be applied in the same way. If the paint has dried, re-wet the area and apply touches of purple on top. Allow the painting to dry, then use an eraser to gently remove any visible pencil lines before removing the masking tape to finish.

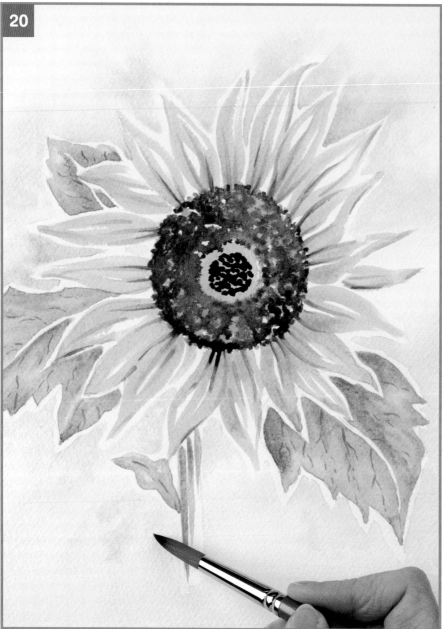

JARGON BUSTER
A **variegated background** is simply one that consists of more than one colour.

In the next project you will learn how to add more shading and detail to orange, yellow and purple pansies.

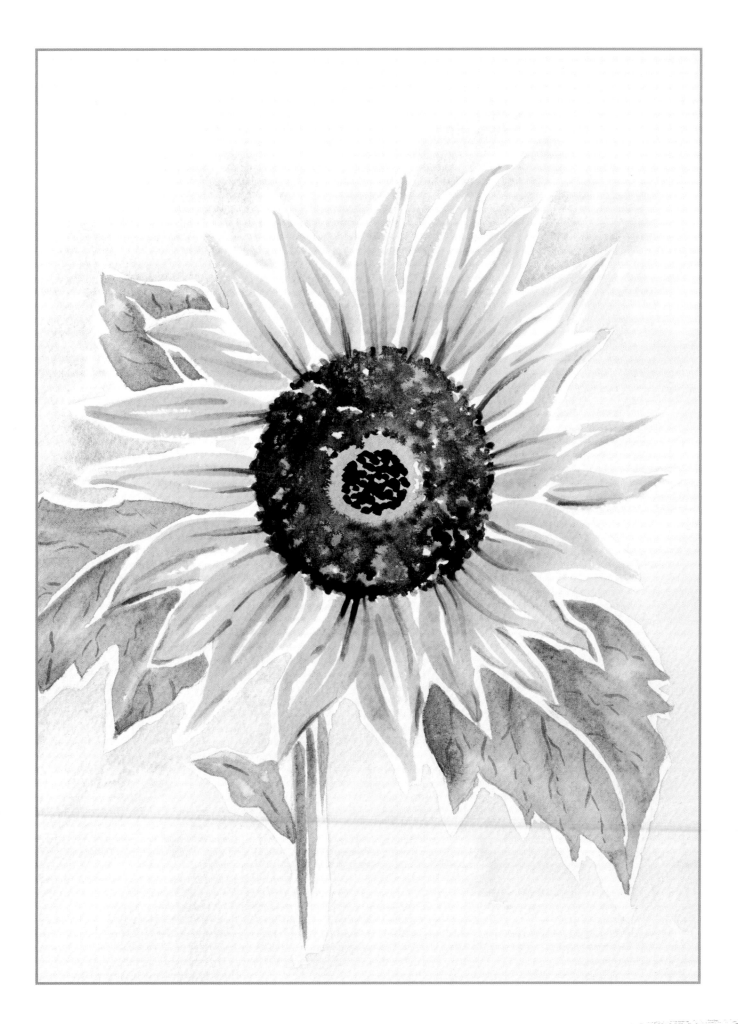

Pansies

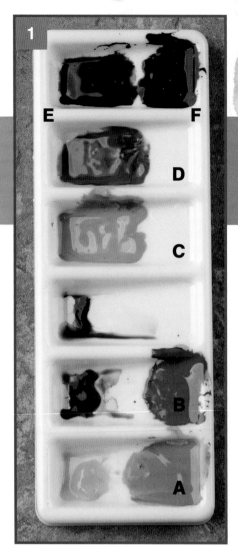

What you learn:

- **How to paint overlapping petals**
- **Painting shadows and highlights**
- **Movement within petal shapes**

1 Prepare the following mixes: orange (A), made from yellow with a little rose; strong orange (B), made from an equal mix of yellow and rose; light green (C), made from yellow with a touch of blue; dark green (D), made from yellow with more blue; light purple (E), made from rose and blue; and dark purple (F), made from an equal mix of rose and blue.

2 Secure the paper to the board using masking tape and transfer the image.

3 Starting with the yellow flowerhead (at the top right), wet the lower petal using clean water and the the medium brush, then apply pure yellow paint, sweeping the brushstrokes inwards to create varied tones.

4 Pick up a little watery light green (C) and add a few light strokes wet-in-wet to give shape to the petals.

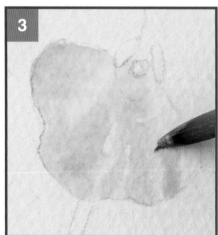

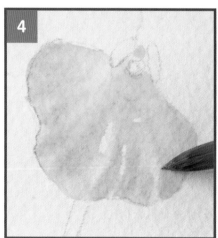

JARGON BUSTER

A **vignette** is a painting which does not extend to the outer border of the paper – instead it finishes with a loose shape.

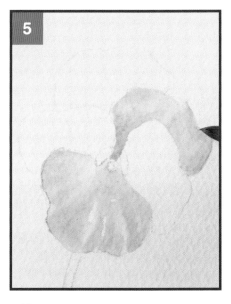

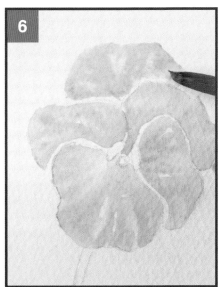

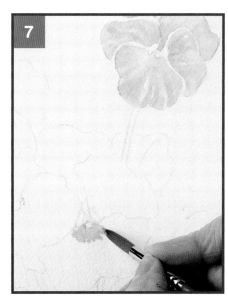

5 Paint the next petal. Rather than working the one immediately adjacent (which will still be wet), work one a little way away, to avoid the risk of disturbing the drying paint.

6 Leave fine gaps of white paper between the petals and continue until all the petals on the yellow flowerhead are completed.

7 Use the yellow paint remaining on the brush to paint the centre of the middle flower wet-on-dry, with a downward brushstroke.

8 Using the orange (A) mix, paint the first petal of the left-hand flower in the same way as the yellow pansy, followed by strong orange (B) instead of light green.

9 Paint the remaining petals in the same way, remembering to avoid adjacent petals until they are dry.

10 Allow the flower to dry, then switch to the small brush and strengthen the tone of the pansy by applying the strong orange mix (B) at a medium consistency over the areas in shadow.

11 Rinse the brush and use the damp bristles to soften the shadowed edge into the background wash. This will emphasise the movement and curve of the petal.

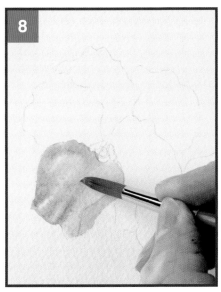

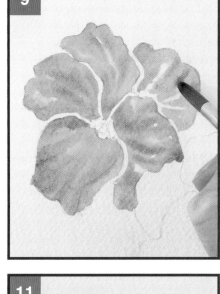

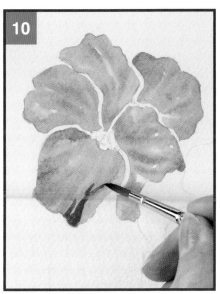

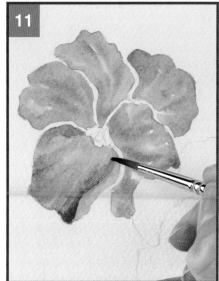

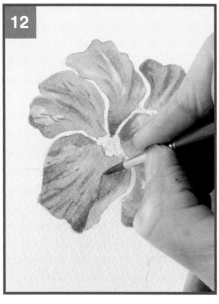

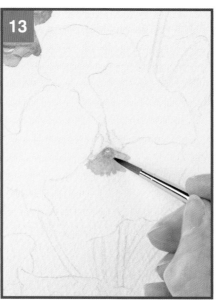

12 Continue strengthening the colour until you have created a sense of form and shape. As well as softening the shadows, small fine textured veins can be added with the tip of the small brush.

13 Use the light green mix (C) to detail the right-hand flower and the centres of the pansies.

14 Paint the top petals of the central flower as described earlier, blending dilute light purple (E) into clean water with the medium brush. Add a little dilute dark purple (F) wet in wet using the small brush.

15 Paint the other second pale petal in the same way.

16 Once the painting is dry, start to paint the remaining petals with the same techniques. Use the same colours mixed with less water to make stronger tones.

17 In addition to drawing the colour in from the outer edges of the petals, draw a stronger, creamy consistency of the purple mix (F) out from the centre, leaving lighter tones in the middle of the petals.

18 Continue until the purple pansy is finished. When painting the lowermost petal, overlap the dry yellow areas.

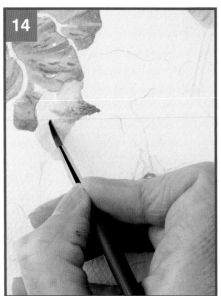

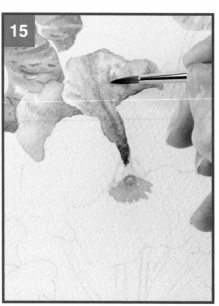

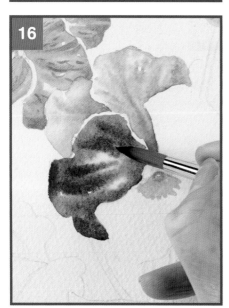

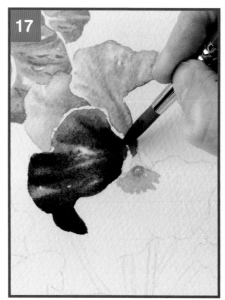

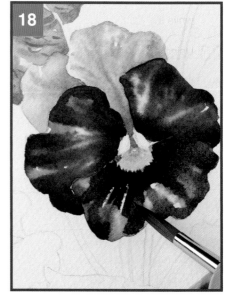

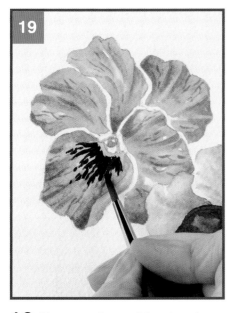

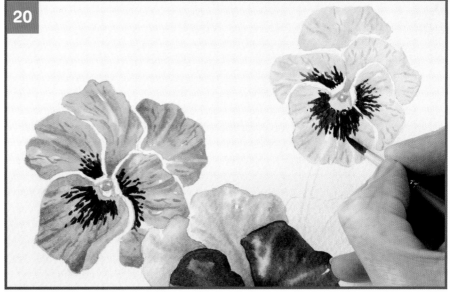

19 Change to the small brush and use the dark purple mix (F) to paint the detail on orange-red pansy. Build the shape up gradually using tiny touches with the tip of the brush.

20 Work outwards from the centre along each petal, then repeat the process on the yellow pansy.

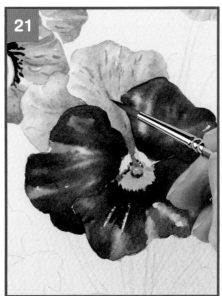

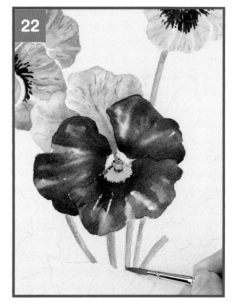

21 Still using the dark purple mix (F) add a little detailing along the remaining white area in the centre of the purple pansy. Finally, add a few fine veins of a dilute purple mix (F) on the top petals.

22 Paint the stems with the small brush and the light green mix (C), adding dark green (D) for shading while the paint remains wet.

23 Using the medium brush, wet the left leaf with clean water, leaving a few gaps of white paper to suggest highlights and veins. Touch in dilute light green (C).

24 Add dark green (D) wet-in-wet. Pull the colour swiftly along the central vein and to the sides, leaving some of the light green and dry areas showing.

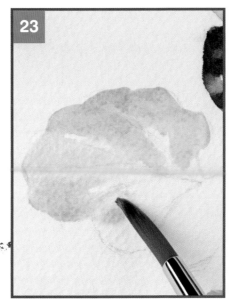

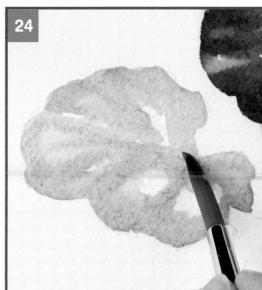

JARGON BUSTER

Highlights are areas emphasised by light, usually achieved by leaving white paper showing.

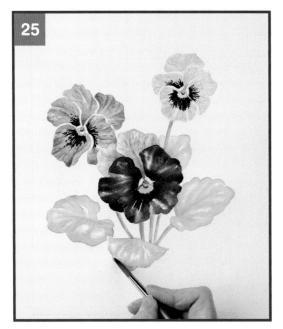

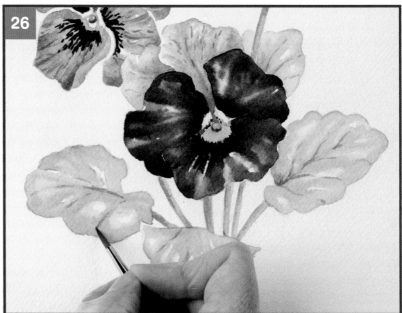

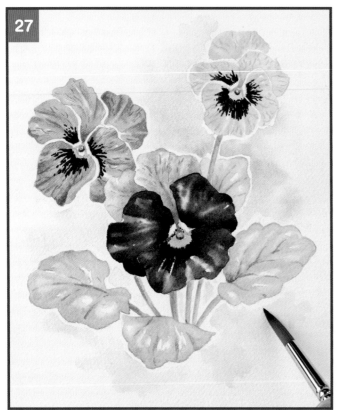

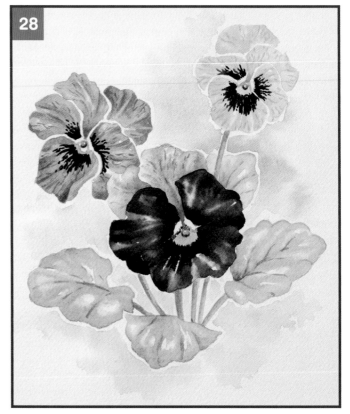

25 Dampen the small brush and use the tip to soften some of the hard edges of the highlights, then paint the other leaves in the same way.

26 Once dry, add veins and details with dark green, applying it with the tip of the small brush.

27 Add a simple background to unify the painting. Working section by section, wet the surface and drop in watery mixes of yellow on the left, orange (A) at the top and dark purple (E) on the right. Add a loose edge of dilute pale green (C) below the leaves.

28 Drop in a dilute green mix (D) on top of the damp green base and allow to dry.

In the next project you will return to painting white flowers, this time emphasising one with a variegated background.

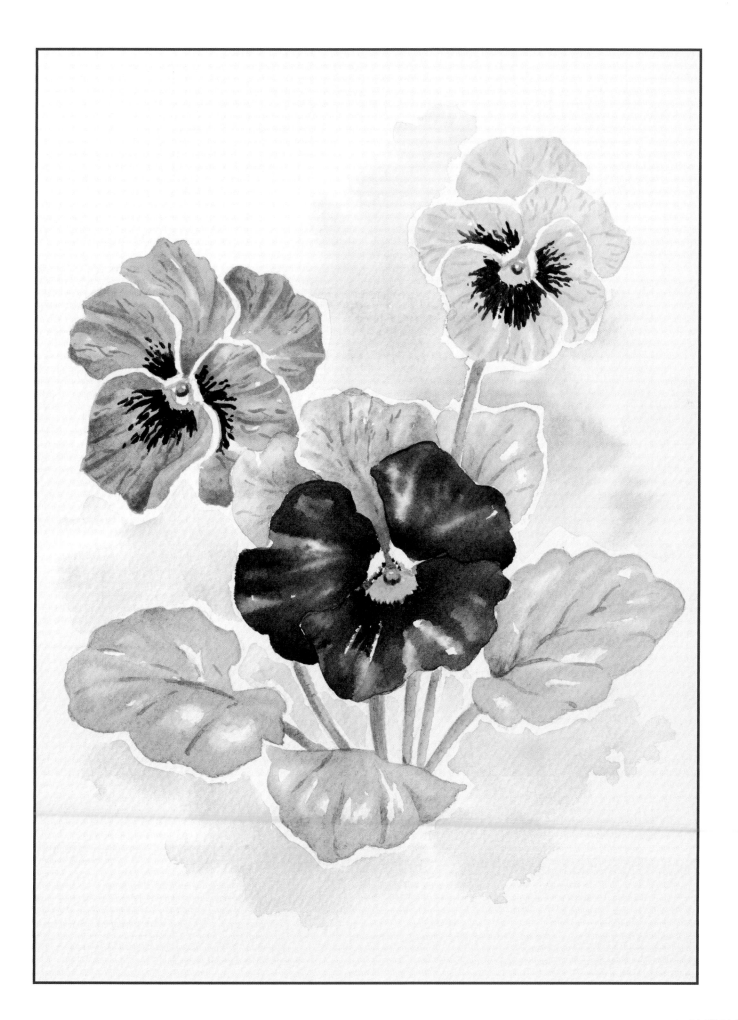

Passion flower

What you learn:

- **How to paint an intricate flower centre**
- **Adding fine detail**
- **Painting soft, undulating leaves**

1 Prepare the following mixes: grey (A), made from rose and blue with a hint of yellow; yellow-green (B), made from yellow with a little blue; blue-green (C), made from yellow and slightly more blue; blue-purple (D), made from blue with a little rose; and rose-purple (E), made from an equal mix of rose and blue with a hint of yellow.

2 Secure the paper to the board with masking tape then transfer the image. Run extra masking tape around the edge of the picture.

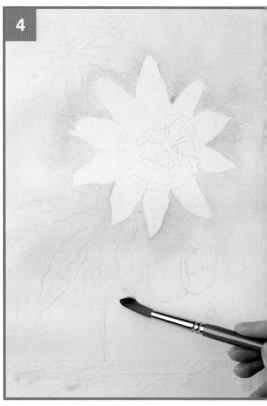

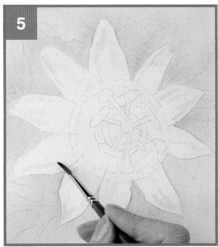

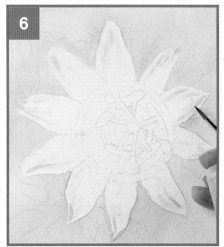

3 Using the large brush and clean water, wet the whole painting except for the main flowerhead. Use the point of the brush to work carefully between the petals. Working outwards from the petals, add dilute yellow to the lower two-thirds of the wet surface.

4 Add dilute blue to the top third, allowing the colours to mix on the surface where they meet. Touch a little into the wet yellow below the flowerhead and, while still wet, add yellow-green (B) in wet-in-wet beneath the lower petals.

5 Add a few subtle marks to the tips of the petals with dilute grey (A) and the small brush. The marks should follow the shapes of the petal, indicating shadows.

6 Once dry, overlay darker brushstrokes using a stronger, less dilute mix of the same grey, painting over parts of the previous brushstrokes.

JARGON BUSTER
Painting over an area that has aleady received paint is called **overlaying** paint.

Tip

Keep the shadows in the petals minimal to help show the brightness of the clean white paper.

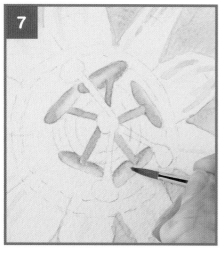

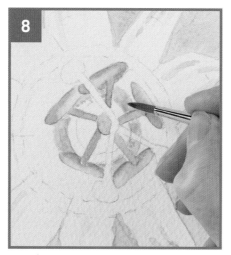

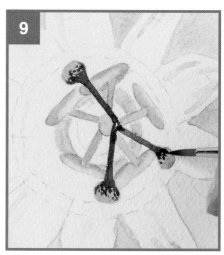

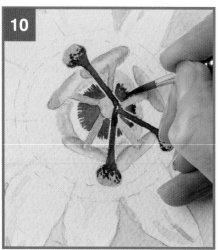

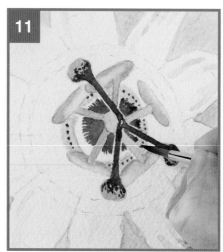

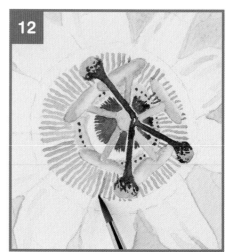

7 Still using the small brush, begin to paint the stamens with the yellow-green mix (B). Use the mix fairly strongly (i.e. not very diluted) to paint areas of shadow, then rinse your brush and use the damp bristles to soften the colour in.

8 Use yellow to paint the inner band, then add a few touches of yellow-green (B) wet-in-wet.

9 Add yellow-green (B) to the rounded parts of the upper structure (stigma). Once dry, paint the remaining area with the rose-purple mix (E). Use the tip of the brush to stipple over the green area.

10 Still using the rose-purple (E), paint short radiating lines out from the centre. Leave fine gaps around the areas you have already painted.

11 Allow the paint to dry, then use the same brush to stipple tiny dots within the yellow ring.

12 Continuing with the small brush, dilute the rose-purple (E) mix and use it to paint fine lines radiating out from the yellow ring.

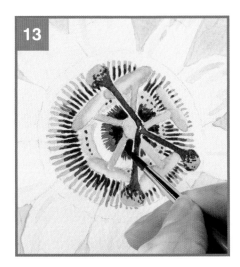

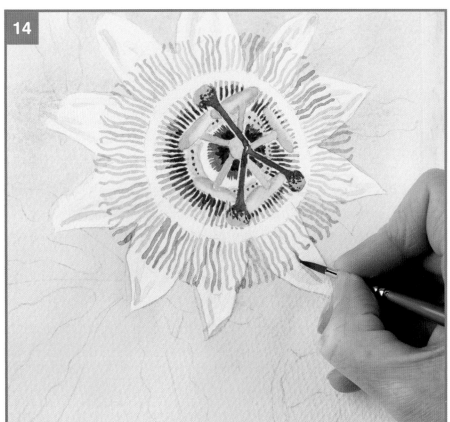

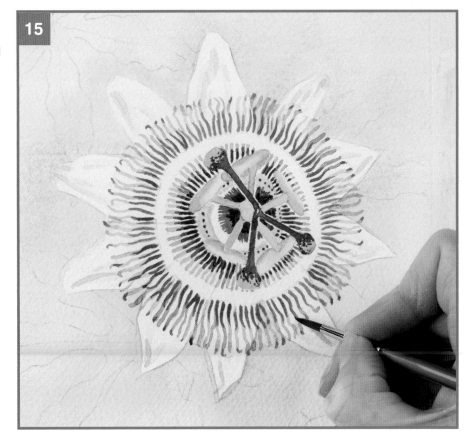

13 Once the painting has dried, use the tip of the small brush to overlay a strong band of a slightly thicker rose-purple (E) mix within the central and outer lines.

14 Paint the outer frill in the same way, using the blue-purple (D) mix. Apply the first layer with more dilute paint.

15 Change to a stronger (i.e. less dilute) blue-purple mix (D) and overlay as before. Finally, add small touches to the tips.

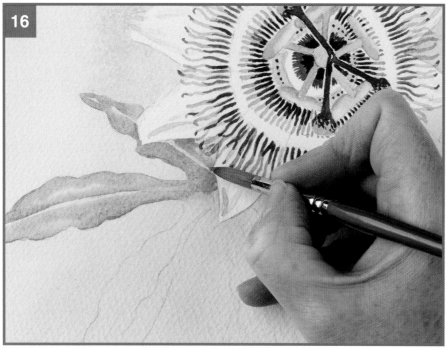

16 Refresh your water. Using the medium brush, apply a base of water on the leaves, leaving a gap of dry paper for the central veins. Apply the yellow-green mix (B) wet-in-wet. Leave areas of light to suggest highlights.

17 Paint the remaining leaves in the same way.

18 Paint the stems with yellow-green (B), then switch to the small brush and add a little dilute rose-purple (E) wet-in-wet for shading.

Tip

Adding a brushstroke of the rose-purple mix (E) on top of a green stem will create a deeper shadow.

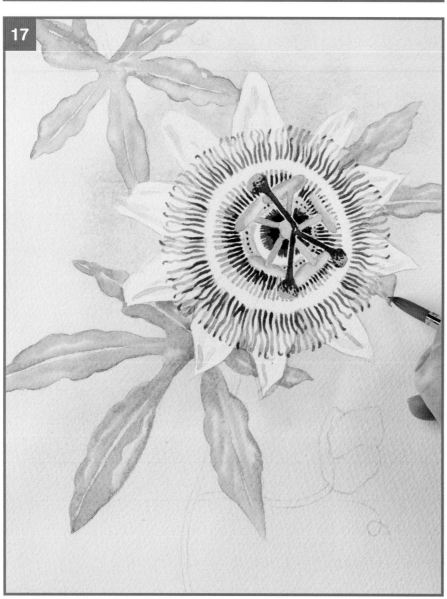

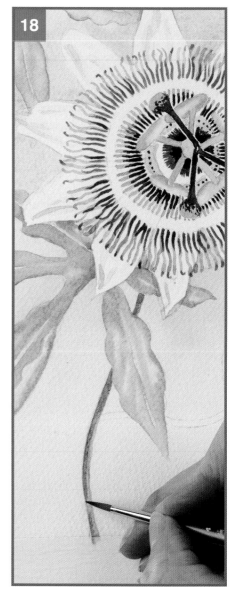

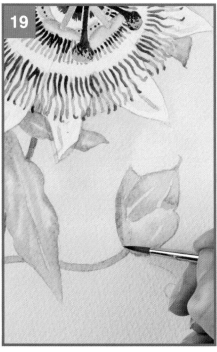

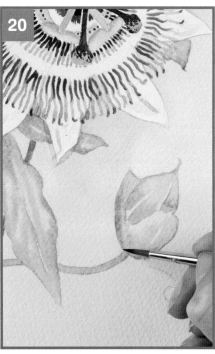

19 Paint the bud in the same way as the leaves, using the medium brush and the yellow-green (B) mix. Leave small gaps as shown.

20 As with the stems, add the rose-purple mix (E) wet-in-wet, reserving it for the outer part of the casing.

21 Paint the remaining stems and add the fine curly tendrils with the small brush.

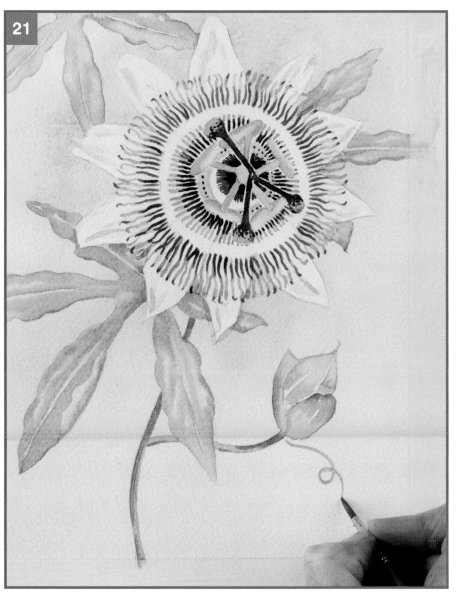

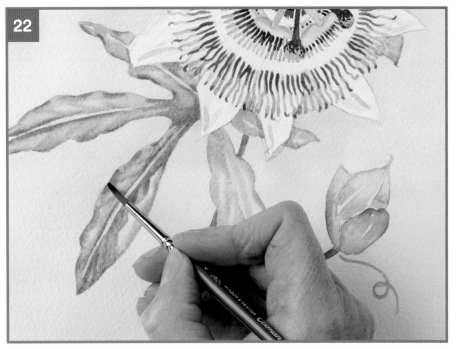

22 Once dry, very lightly re-wet areas of the foreground leaves with clean water using the medium brush, then change to the small brush to add details with blue-green (C) to suggest their undulating shape. Use sweeping strokes for the veins and broken brushstrokes on the edge.

23 Repeat the process for the tendrils and bud. Instead of using the blue-green mix on the top leaf, wet and apply pure pale blue so that it appears softer in the background.

24 Add blue-green (C) on the stamens to strengthen the shading, then allow the painting to dry completely before removing the masking tape to finish.

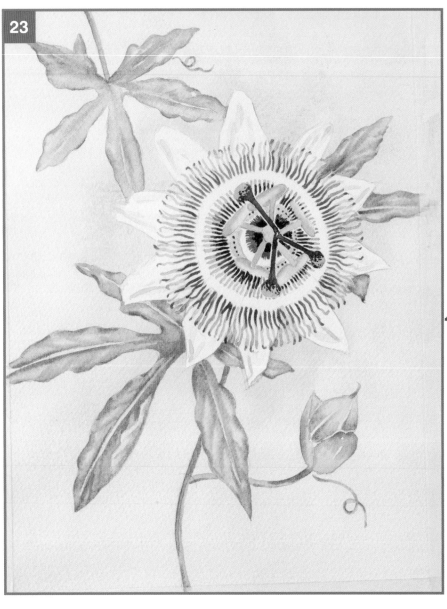

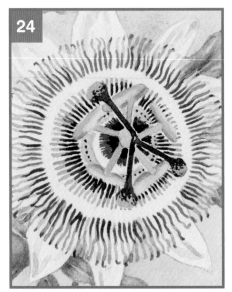

JARGON BUSTER

Strong or warm colours, as in the lower green leaf in this painting, appear to come forward while the pale blue-green leaf appears to recede into the blue background. This effect is called **aerial perspective**.

Our final project will give you the opportunity to paint a beautiful, detailed rose using the techniques you have learned while painting the other flowers in this book.

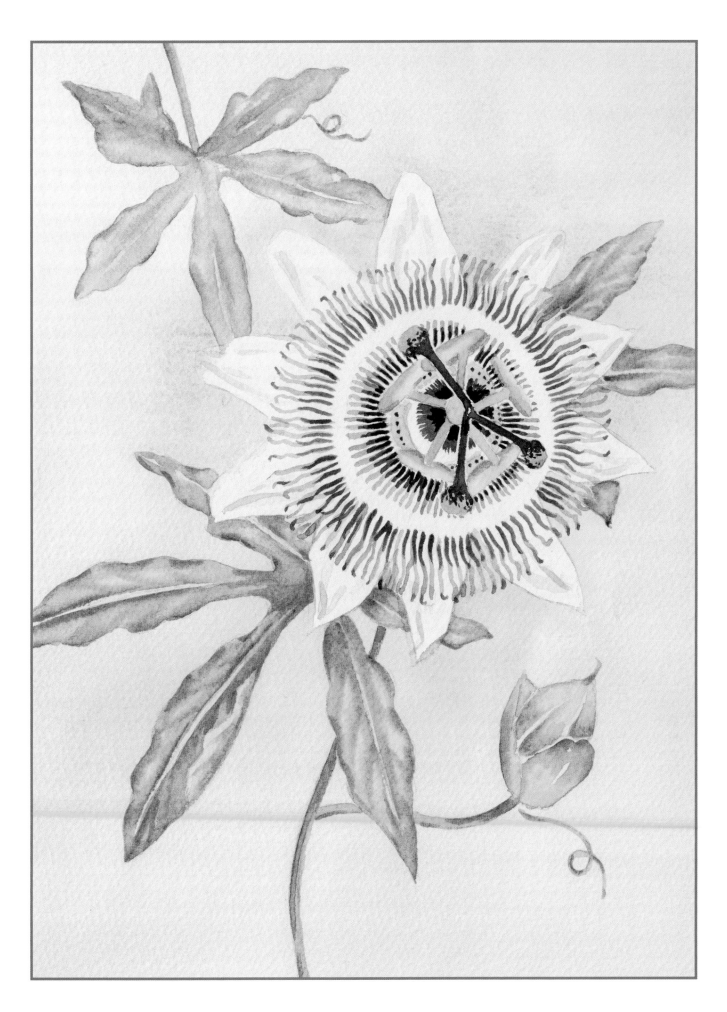

Rose

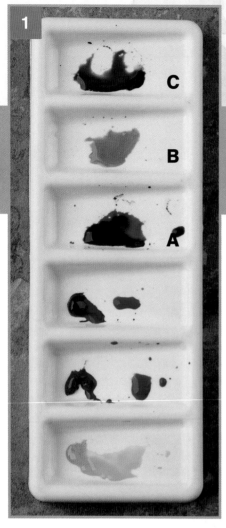

What you learn:

- Adding deep shadows in complex areas
- Painting serrated leaves
- How to choose background colours

1 The mixes you will need to prepare for this painting are as follows: cool pink (A), made from permanent rose with a little blue; yellow-green (B), made from yellow and a little blue; and blue-green (C) made in the same way as the yellow-green, but with proportionally more blue.

2 Secure the paper to the boards using masking tape, transfer the image, and apply masking tape round the pencil edge.

JARGON BUSTER

A background in a **complementary colour** to the flower (that is, opposite the colour of the flower on the colour wheel) will enhance the colour of the flower.

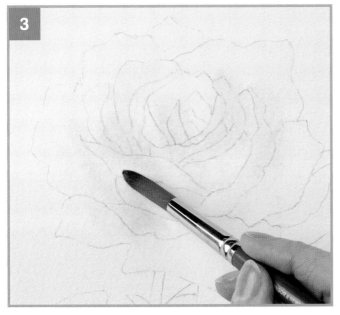

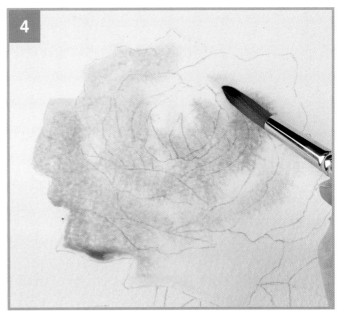

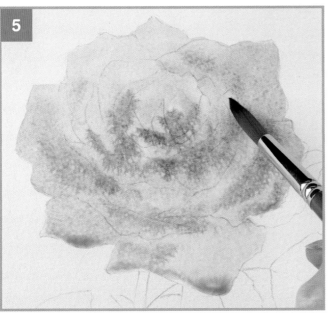

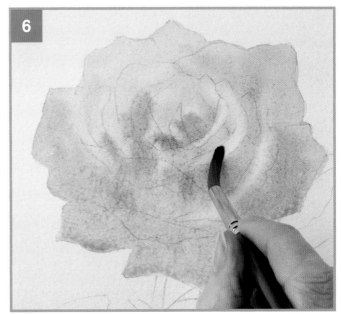

3 Use the large brush to wet the entire surface of the flower head with clean water. Touch in dilute yellow in a rough spiral shape, working from the centre outwards.

4 Rinse the brush and repeat the process with dilute permanent rose, leaving areas of yellow showing through.

5 While the paint is wet, add slightly stronger touches of permanent rose in the centre.

6 Rinse and remove excess water from your brush while you leave the painting to dry for just a few seconds. When the paint is merely damp, lift out some colour by pressing the brush firmly on to the surface and drawing it along the edges of the petals to remove the colour.

7 Repeat to create the basic form of the flowerhead as shown, then allow the painting to dry.

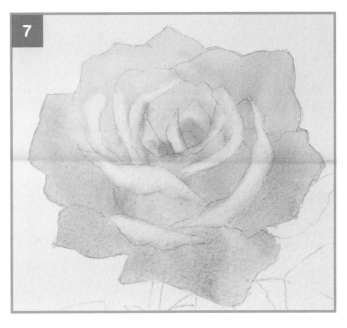

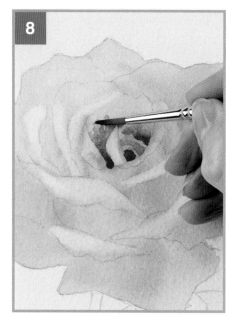

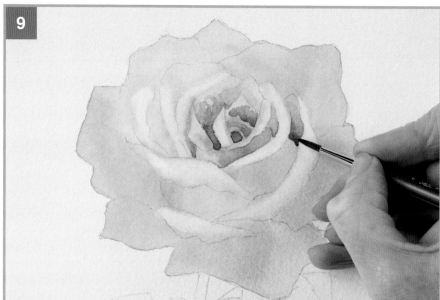

8 Paint in the shadows between the petals in the centre of the flowerhead using the small brush and permanent rose. Apply the paint wet on dry and fade it out with a clean damp brush.

9 Working from the centre outwards, continue painting the shadows. Introduce the cool pink (A) mix as you begin to work away from the tightly-packed central petals.

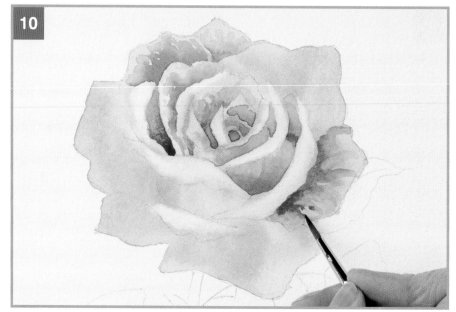

10 Continue working outwards painting the shadows, following the loose spiral you established earlier. Suggest the curves of the petals by following their shapes with the brush. Introduce progressively more of the cool pink (A) mix for the outer petals.

11 Continue painting to the outermost petals. Leave small gaps between brushstrokes to suggest texture and be careful to leave untouched any areas from which you lifted paint in step 6.

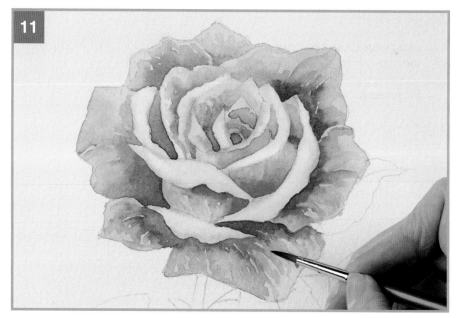

12

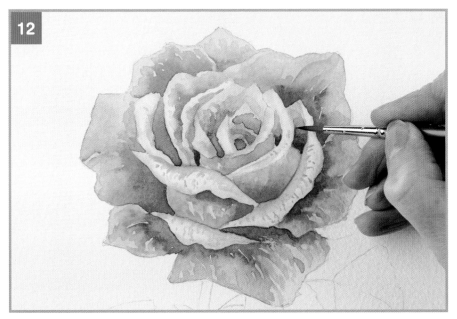

13

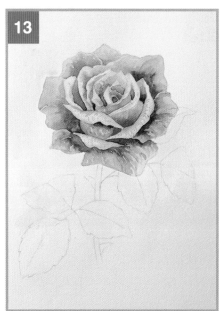

14

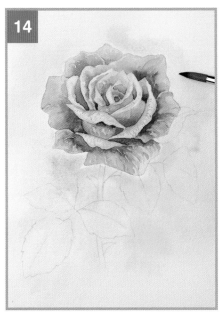

15

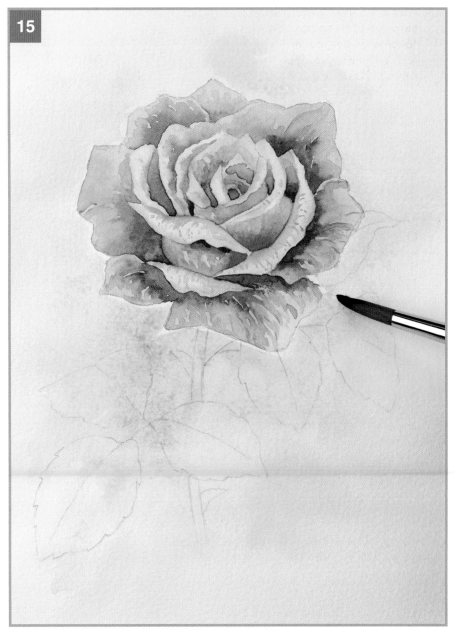

12 Add very subtle shading and texture to the highlighted petals using more dilute mixes, softening the colour in with a clean, damp brush. Add stronger cool pink (A) in the recesses near the centre.

13 Allow the flower to dry, then wet the background using clean water and the large brush. Leave a fine gap around the rose, then paint in dilute yellow.

14 While the paint remains wet, add some dilute yellow-green (B) with loose dabbing strokes.

15 Add some dilute blue touches here and there, then allow the painting to dry completely.

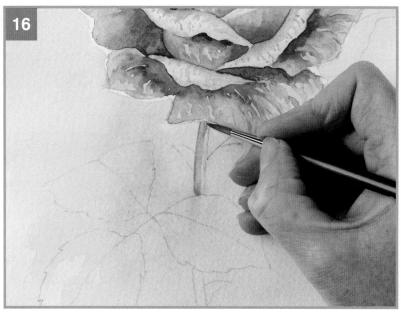

16 Use an eraser to remove the pencil lines within the flowerhead, then paint the upper part of the stem with yellow-green (B) and the small brush.

17 Avoiding the leaf, continue painting the lower part of the stem with the yellow-green (B) mix. While this remains wet, run a damp brush along the edge of the paint so as to fade it out to the lighter side. Add a hint of the cool pink mix (A) on the shadowed side.

18 Allow the stem to dry, then paint the thorns using cool pink (A), leaving a gap for the highlighted shiny area. Add a stronger mix wet on dry to suggest the shadows on the undersides of the thorns.

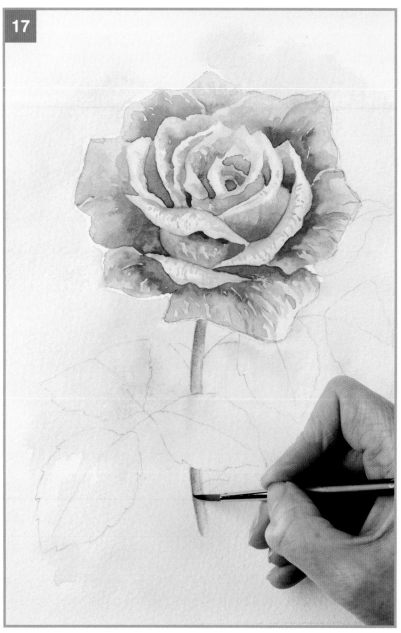

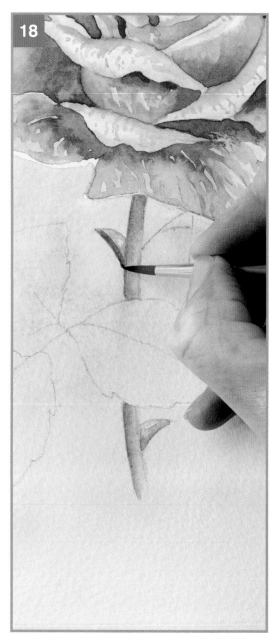

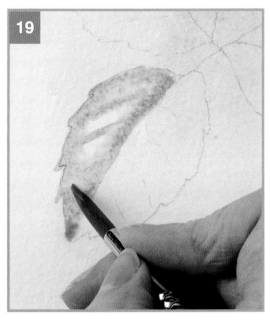

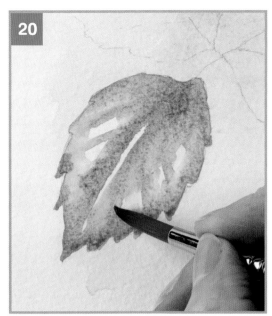

19 Use the medium brush to wet the lowest leaf with clean water, leaving gaps to suggest the shiny highlights.

20 Add blue-green (C) wet-in-wet for shading, drawing the brush out towards the serrated edge of the leaf.

21 To finish the leaf, use the small brush to accentuate the serrations by adding hints of cool pink (A) at the very edges.

22 Continue painting the other leaves in the same way. If you miss a highlight, you can use a damp brush to lift out the paint.

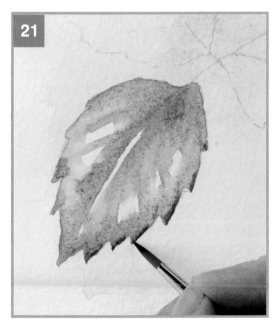

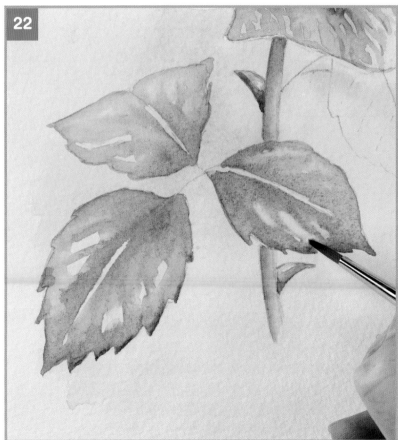

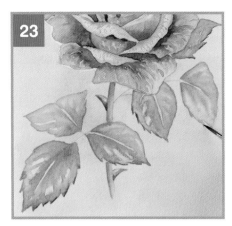

23 Complete the remaining leaves in the same way as in steps 19–22.

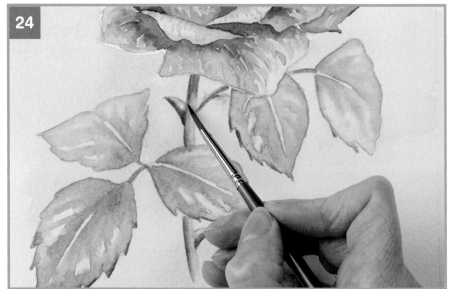

24 Add the fine stems that connect the leaves to the main stem, using the small brush to apply yellow-green (B) followed by cool pink (A) wet on dry.

25 To finish, use some cool pink (A) to strengthen the main stem under the flowerhead, then change to dilute blue-green (C) to reinforce the shadow on the thorns and to indicate fine stronger veins. Allow the painting to dry, then remove the masking tape.

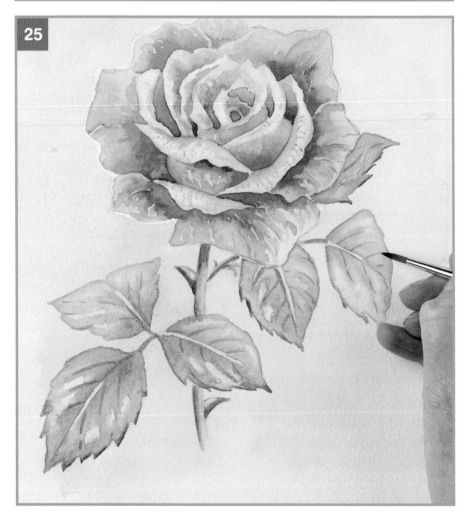

The finished rose. Compare this with your tulip painting to see how far you have progressed!

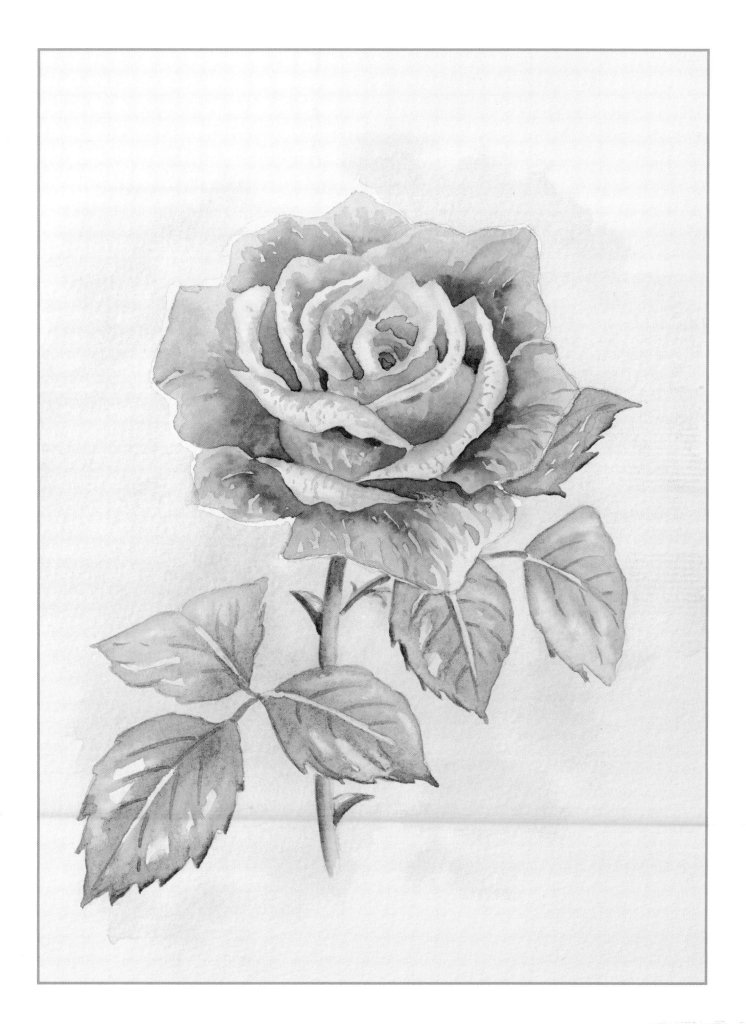

Transferring a drawing

The paintings in this book are shown at full size so that you can trace the drawings from them. This will allow you to transfer them to your watercolour paper using the method shown here.

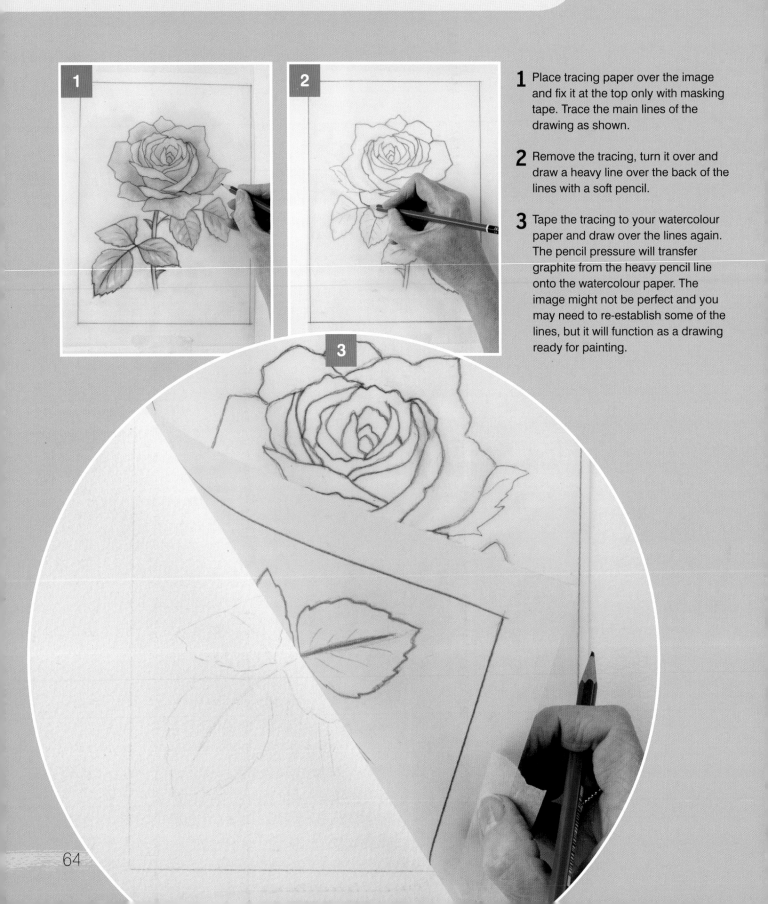

1 Place tracing paper over the image and fix it at the top only with masking tape. Trace the main lines of the drawing as shown.

2 Remove the tracing, turn it over and draw a heavy line over the back of the lines with a soft pencil.

3 Tape the tracing to your watercolour paper and draw over the lines again. The pencil pressure will transfer graphite from the heavy pencil line onto the watercolour paper. The image might not be perfect and you may need to re-establish some of the lines, but it will function as a drawing ready for painting.